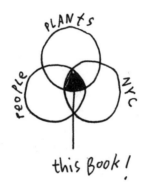

PLANTS

PeoPLe

NYC

this Book!

Nature expresses itself
from all quarters & in all directions
as it goes about its work of creation.

The integrity & rising intensity of the inner impulse,
the creativity which sometimes issues in complexities of
form far beyond the need of mere survival gives natural
things a degree of autonomy & a measure of intrinsic value.

Nature
is destined not for particular... ends,
but rather for ... the internal satisfaction of
wholeness

— Johann Wolfgang von Goethe

Searching for Sunshine

Finding Connections with Plants, Parks, and the People Who Love Them

ISHITA JAIN

FOREWORD BY WENDY MACNAUGHTON

PA PRESS

PRINCETON ARCHITECTURAL PRESS · NEW YORK

Contents

FOREWORD
Wendy MacNaughton

Searching for Sunshine is a rich, visual exploration of plants, people who love them, and the city of New York. Sure. That's true. But unlike the countless other catalogs of plants and the billion other big city travelogues, Ishita Jain's book is a captivating demonstration of how to explore the natural world inside a big city. It's a lesson in slowing down, becoming curious and open, how we can explore our surroundings—and how we are changed by the process.

I first met Ishita when she approached me to be her graduate advisor in her last year at New York's School of Visual Arts. I agreed, and over the next year we met for an hour or two every week. I encouraged her to get out of her studio, talk to strangers, bring her supplies outside and draw everything she noticed. It took a little time but eventually she did.

I remember the first time she approached someone to interview them. She told me she'd been drawing at a small neighborhood park where a group of older women gathered to garden. After a few days of lurking, she decided to approach them. Clutching her sketchbook, she awkwardly interrupted their conversation and introduced herself and asked about their gardening. Much to her surprise, they did not bite, shout, or shoo her away. Instead, they were delighted she'd taken such an interest in

their activities and asked her if she'd like to join in. And with that, she was hooked.

Each week, when the weather allowed, Ishita would venture out with her supplies and return with stories of new risks and rewards. She'd tell me she'd learned a new fact or heard a great story. She'd plopped down in a public park for a whole afternoon and made magnificent drawings in pen, watercolor, and ink. Each of these adventures allowed Ishita to discover what she was excited about. What she was afraid of. What she was most interested in learning more about. How she wanted to move through the world and what she wanted to tell about it. And I, based in California, got a front row seat to this in-depth exploration of New York, and to an artist's evolution as an observer, storyteller, and active participant in the world.

Ishita's focus on plants and their people grew quickly. Her unique visual and journalistic style took root. The result is a joyful contribution to the field of visual storytelling, a masterful thesis that continued to evolve and deepen until it became the book you're holding in your hands. In *Searching for Sunshine*, Ishita uses the practice of drawn journalism as a way to explore her new home of New York City and to deepen connections to her personal history and home of origin in Delhi, India.

For the uninitiated, drawn journalism is the practice of creating visual stories on location out of sketches, interviews, and observations of the artist/journalist. What drawn journalism does so well that other mediums do not is that it puts the viewer in the place—and in the body—of the drawer. The visible hand of the artist slows us down. We take a deep breath. We look closely.

Drawing on location forces the artist/journalist to be physically present in one spot long enough to get a real sense of the place. The longer you stay in a place, the more you see. The more you get to know the place and the people. The more you understand what's really going on. When we look at a drawing done on location, we step into the artist's shoes and experience what they experienced. It is the opposite of objective reporting. It is a human experience. It is a natural one. And it's why *Searching for Sunshine* is such a captivating and unique book.

To be good at drawn journalism you have to embrace being an outsider. In this field, you want to have fresh eyes at all times. You have to overcome your fear of looking silly. Of not fitting in. Of sticking out. Of making mistakes. Of saying the wrong thing. Of your work being judged harshly by any Joe Schmo on the street. Because all those things will happen every time you go out to draw and talk with people. But if you can get past that, the whole world waves and calls you over to chat.

Ishita combines the practice of drawn journalism with nods to anthropology, botany, design, and illustration, mixes them with a little paint and water, and creates a unique and captivating visual adventure. Through skillful, loose, life-filled drawings and in-depth interviews, Ishita examines New York's natural world from every imaginable angle: science, design, community, art, food, and service. Her curiosity becomes ours. And after we're done reading the stories in this book and looking closely at the gorgeous illustrations, we can't help but see the world differently and find ourselves wanting to head out and explore too.

In *Searching for Sunshine*, the focus is the flora, but the people are the real subject matter. The natural world we seek to find hiding in the city, that soil and light we cannot live without. Ishita's book is a beautiful guide to a city, or plants, or even people. But it's also much more, a primer on how to look more closely at the world around us—from the microscopic to the meta, from flowers that travel halfway around the globe to the humdrum of public gardens, from bare fingertips caked in mud and soil to neatly packaged specimens in laboratories, from her hand to our eyes. There's so much beauty here to discover.

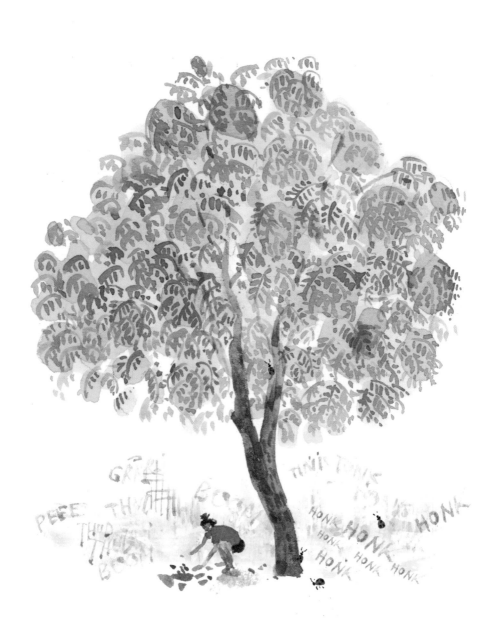

INTRODUCTION

I grew up in an industrial area surrounded by factories, noise, and flyovers in New Delhi, India. But our house had a beautiful garden, and amid honking cars and whirring machinery, I spent hours searching for ladybugs or special stones and mixing wet and dry soil and sand to create my own clay concoctions. I never felt alone there.

I remember distinctly the day the garden was plowed to make room for the expansion of our factory. However, my *taiji* (aunt) and *tauji* (uncle), both of whom are avid gardeners, reclaimed the space we had on our terraces. Within a few years they transformed a gray, old rooftop into a green haven, and they made sure I was part of that process. I am sure that my love for green spaces started with them, at home.

In 2018, I moved 7,299 miles from Delhi to New York City to study illustration. I came from one kind of chaos into another. I still find the towering, gray skyscrapers a bit of a visual shock. Among these giants fighting over every inch of space in the city, the parks offer a relief where I can feel a bit at home. My first winter here I was overcome with the blues. Daylight saving? Seriously? The diminished sunlight combined with bouts of homesickness made me miserable.

There is nothing quite like the feeling of warmth on your skin and wind in your hair on an unexpected false spring day. It gives you hope that good things are soon to come. After the long winter, my first summer in the city felt like an explosion of color and energy, and I felt like I was beginning to understand the temperament of the city and why people like it here.

I am very much an outdoorsy person. Being outside, on foot, is how I start building a personal relationship with the spaces that I inhabit. When you live in a dark apartment with a glorious view of a brick wall, like I did in my first year in New York, every chance to be outside is an adventure. This search for sunshine inevitably led me to parks. Walks in the park became a way to observe new plants, trees, birds, and animals; to bump into people and notice regular characters; and to reflect and talk to myself.

There are days when my head and my heart are racing to keep up with the pace of life in this city, but somehow when I walk into a green space, I can hear myself exhale. People always seem more approachable and friendlier in parks than on the streets, and this got me thinking: What is it about green spaces in cities that evokes a sense of calm?

Plants are intricately linked to all aspects of our life. The food we eat, the air we breathe, the inspiration we seek—everything comes from nature. Often, we forget that though many of us live in cities, surrounded by walls, adhering to strange timetables,

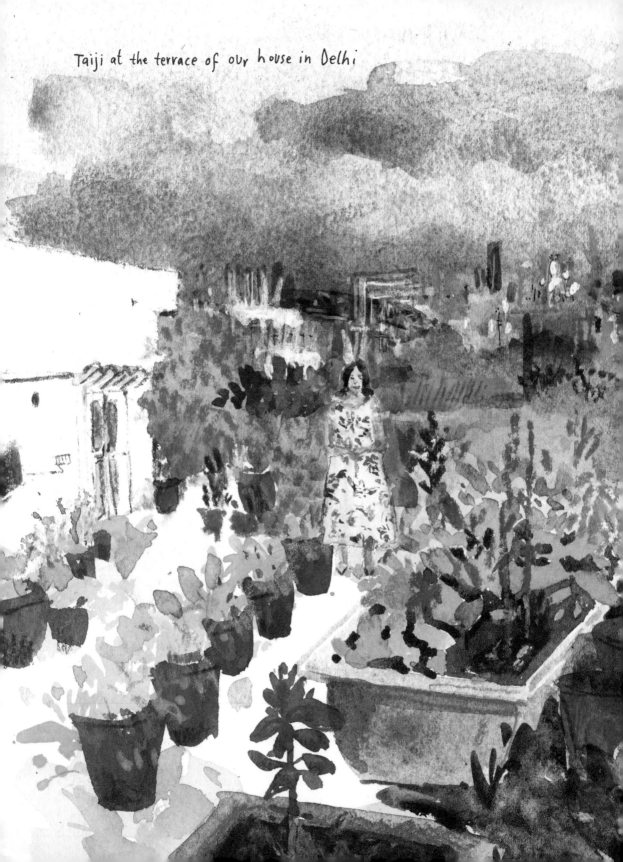

Taiji at the terrace of our house in Delhi

we remain natural, growing, ever-changing beings. Whether it's our primal need to connect with nature or whether we just simply need plants to breathe, I am curious about people's personal experiences with plants, gardens, forests, and green spaces. To me, people seem happier in nature, and I wonder what it is about plants that makes them happy.

Plants exist in a different sense of time. You cannot force a plant to be productive and produce ten flowers by 9 a.m. on Monday morning. No incoming election, exam, deadline, or calamity can change a plant's innate timetable. This became especially clear during the pandemic—the world came to a halt, but life did not pause in the plant world. Spring, summer, fall, winter came and went, and that was grounding and reassuring.

The world around us is changing at a rapid pace; forests are burning, cities are flooding, landscapes are changing. My hometown of Delhi no longer has the crisp winters and the clear skies of my childhood. It can be overwhelming and disheartening to see the news. I went around New York, this city that I currently call home, and interviewed gardeners, botanists, florists, foragers, herbalists, scientists, city planners, and asked them about their experience of working with the natural world, the impact of nature on their everyday lives, and why plants make us happy.

It is my hope that the stories shared in this book remind us that we shouldn't have to care about plants just because they might go away, but because they can also offer beauty, wonder, connection, and new perspectives on time, change, and what it means to live.

A note on process

This book is the result of several partnerships. People trusted me with their stories, and I listened and drew. All the interviews, save one, were conducted in person over the course of one or multiple days.

The interviews were informal conversations that I then condensed and edited down to share in this format. It is important for me to be able to meet and draw in person for several reasons.

When I meet someone in person, I can have a candid dialogue, which is different from just asking questions. When I hear people's stories and share my own in response, we build trust and our conversation goes deeper. When I meet people in their own personal or professional spaces, I also get to see their personality in those spaces. I can look around and make connections between nooks, books, specimens, tools, and objects of visual interest.

Things that spark visual interest but might have no connection to what is being spoken about in the interview can sometimes create interesting juxtapositions.

Drawing on location is more about looking and feeling than about putting an exact representation on paper. It is a way to observe, and I find myself acutely present in the environment where I draw. I prefer to draw in a park rather than drawing from a photograph because the presence of that particular day, the amount of light, the people around, the wind in the air, the music that plays, everything seeps into the drawing. If it is cold, my strokes will be faster and quicker, if a song I love is playing nearby, it might become a part of the drawing. No two

drawings are the same—they are reflections of different moments in time.

Many of the drawings in this book were made on location. Some were just sketched on location and colored in my studio. Others, in the absence of good weather, were made from photographs that I took in person or photographs that were shared by the interviewees.

Lastly, this book is not an encyclopedia about plants and plant people in New York. It is a book about my own search for sunshine—literally and metaphorically. I am seeking people and places that shine a light on different ways of living. It is part of my search to understand my own primal nature that feels joy and connection to the world, in simply…living. In living lives that are fueled by productivity, purpose, success, money, and very real day-to-day struggles, it is easy to lose connection with experiences that simply make us feel good. In speaking with people who have chosen to work with nature, and therefore observe a different pace of life altogether, I learned from their own stories of finding connection in this wild world, and I hope that you will find your own ways too.

... plants make life on earth possible,
after all, no plants, no people.

Dr. Barbara Ambrose

Botanist, New York Botanical Garden

One of my favorite places to visit in New York City is the New York Botanical Garden (NYBG) in the Bronx. When I first began to explore the idea of developing this book, which really was an excuse to get me out of my studio and closer to nature, I went to NYBG to warm up and get some inspiration.

Dotty, spotted begonias, flaming red *Aphelandra flavas*, and giant elephant ears were swaying in the breeze. Botanical forms have inspired artists across the centuries, and I, too, love drawing plants. After all, who can resist the charms of lush green organic shapes, delicately unfurling petals, and a range of natural hues that could put your paint-mixing skills to the test.

I have always enjoyed painting botanical subjects and lush landscapes for fun, but I was never able to take my paintings seriously. Plants are such exquisite pieces of art—what more am I adding to the world when I use my time to paint plants? I was convinced that plants and flowers are "indulgent" subjects to draw because there was no greater meaning for me beyond the pleasure that comes from their beauty. Yet, the time spent drawing gardens is extremely peaceful and fulfilling. In the past, I struggled with this contradiction and held myself back from devoting time to developing a series of plant studies.

As I walked through the gardens and greenhouses, seeing one thing of beauty after another, I came face to face with a large backlit board that said "…plants make life on earth possible, after all, no plants, no people." And that was it. My second-grade science lessons came rushing back, and I felt the gravity of this not-so-little fact that I had known all along. Sometimes in the search for bigger things and meanings, one forgets the simplest of truths.

Being amid this lush greenery from all parts of the world reminded me of this innate connection with the natural world. When surrounded by such beauty, I didn't feel despair about the changing world. Instead, I felt hope, joy, curiosity, and wonder about the world that we live in.

So I started right there at the NYBG and spoke with Dr. Barbara Ambrose, director of laboratory research and associate curator of plant genomics at the NYBG. I was curious to know what it's like to work with plants in a clinical setting. It must be so different from working in the field with live, breathing, and changing forms, and so Dr. Ambrose and her team explained their search for answers about life and evolution deep within the veins of buds, flowers, and leaves.

when you work in a lab...

DR. BARBARA AMBROSE

... you realize how little we know about the world.

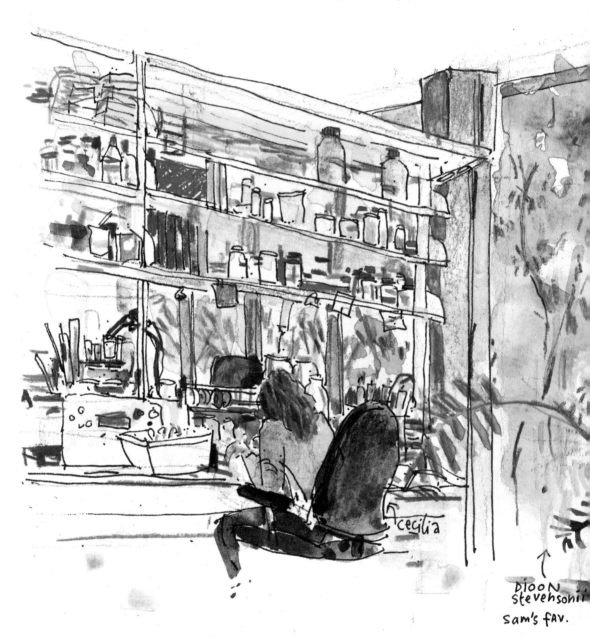

ARAUCARIA
AUGUSTIFOLIA

another Dioon.

we are all joined.
we're all built
of the same nucleotides.
EVERYthinG.
it is just different the way
they're strung together & that is
what makes us
DiFFEREnt

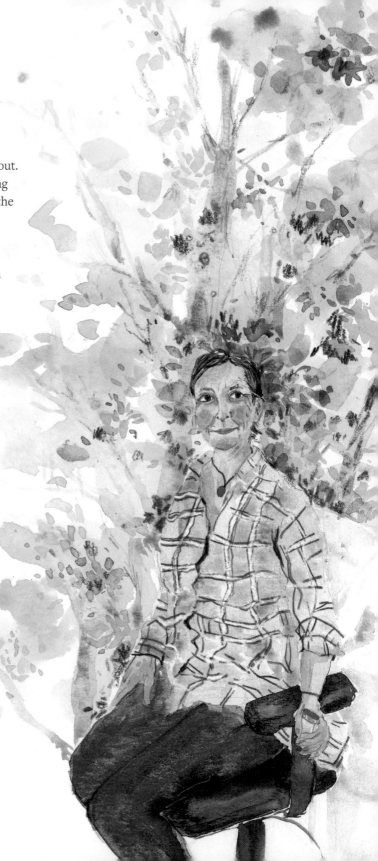

I like puzzles. I like to figure things out. It's like this big, huge puzzle of trying to figure out life, like going back to the naturalists of the 1800s, and people studying in their gardens. [Gregor] Mendel figured out genetics from studying pea plants. Charles Darwin came up with this theory of evolution by just going out and studying the natural world, but also his garden. Mutation theory was discovered in plants. All of these fundamentals to life—what's the cell, what's the nucleus, which mutation—a lot of those were discovered in plants because they're easier to study, they're in your backyard, and people were looking. These fundamental discoveries are common to all life, and I think people forget the commonalities of the fundamentals of life—genetics, evolution, everything. We're all subject to the same forces.

Dr. Ambrose said that the work done at the Pfizer Lab is a team effort. She introduced me to some of the other botanists who work with her at the lab.

TYNISHA SMALLS

I really liked learning about the genetics behind how things know exactly, like, "I'm going to be an eye" or "I'm going to be an arm." So I wanted to go into development.

SAMANTHA FRANGOS

I really like getting to the source of things. I'm always asking where did all this start? It's just so fundamental.

CECILIA ZUMAJO

I grew up in Colombia, so I was exposed to a diversity of plants all my life. And it was just amazing to me. How do all these forms and shapes get to be and why does it happen?

There are about 400,000 known plant species. We know
that there already exists ten times more plant species than
vertebrate species. But then there's a predicted 80,000
plants we don't know and so the thing that's concerning
is we need to catalog those before they're gone.

 People have plant blindness. They don't see the plants
that are around them. If you showed somebody a painting
or a photograph of a huge field and there was a bunny
rabbit right in the middle of it, everyone would zoom in
on the bunny rabbit, but they wouldn't see the 500 species
of plants around them.

People only notice plants
when they are gone.

Plants have survived for hundreds of millions of years, right through massive changes in the climate, in temperature, land masses coming together, crashing together, and they've survived. So how do they do it?

DIOOH
SPINULOSUM
& CONE +
NEW APEX
P. W. B.
GOLD SEAL

→ name
CROSS ← tK10
SECTION ← CoS
16 -4
nth no. of
CROSS SECTION → Cecilia Zump
NAME OF
THE PERSON WHO → June. 25. 2017
MADE THE SLIDE
DATE

ILLICIUM
FLORIDANUM

Macrozamin

CJC

GOLD SEAL

Macrozamin

CJC

M. lomandroides
LF- XS
1-1

NEW YORK
BOTANICAL GARDEN
Smilax sp.
Liliales

Smilacaceae
M Thadeo Sept 2010
safranin 95 %.
NYBG

Zamier angustissima - stem.
ovule
Cuba. CHARLES J. CHAMBERLAIN

I look at a single cell before the flower is formed, and then after several cell divisions I look at it again and again, so I get to see how the form develops through time. I'm really interested in the evolution of development. How do changes in development give you changes in form? What are the genes that build those structures and how do changes in those genes give you differences in structure?

How do flowers develop? How do seeds develop? How do you build leaves? How do you build fruits? I try to understand the logic of plant diversity, all the way down to what the form is.

Why?

Because you can't save what you don't know.

I want to dispel the notion that
you can't find nature in the city.

Georgia Silvera Seamans

Director, Washington Square Park Eco Projects

Before the temperatures began to drop, I decided to spend what was perhaps my last comfortable outdoor drawing day of 2021 in Washington Square Park. On a bright, sunny October morning, I arrived at the park and sat engrossed till the evening, watching the rhythms of the park unfold.

The park has its own tides. I witnessed the watchful gaze of babies in their strollers accompanied by nannies, the awkward albeit enthusiastic sprints of those new to the joys of walking, and the more seasoned and steady focus of dog walkers. As the sun moved overhead, the inevitable line for the famed Dosa Man began to snake around one corner of the park.

I found a spot in the sun and began to draw. A few pigeons swooped lazily around the arch, some deep jazz notes began to drift in, and the afternoon sun made rainbows in the fountain. Students sauntered in, and the morning playground of babies morphed into packs of lounging teen-agers. People began scurrying into the park and it felt like the backstage of a carnival. An acrobat on the ledge of the fountain broke into headstands, a mobile installation with stories and the innermost secrets of complete strangers strolled in, and the ever-present aroma of weed seemed to hit new highs. The jazz gave way to electronic beats and people began to groove. Performers in wildly exuberant, colorful, and flowing outfits strutted by, and skateboarders whizzed around the fountain.

I have always perceived this park as a party park. There is usually commotion, chaos, music, and something mildly shocking happening. Pride parades, Free Britney concerts, protests, and free joints for fully vaccinated New Yorkers. In other words, people seem to be at the forefront of this park, and I have never really paused and thought of it as a natural space. So when I came across the Local Ecologist—a blog of wide-ranging urban ecological ruminations by the director of Washington Square Park Eco Projects, Georgia Silvera Seamans—I paused, and I read.

Georgia's writings and photographs are quick but meticulous accounts of nature in the city. I wanted to know what drew her to keep revisiting this very urban natural space and what drives her to keep documenting and sharing the life that she encounters.

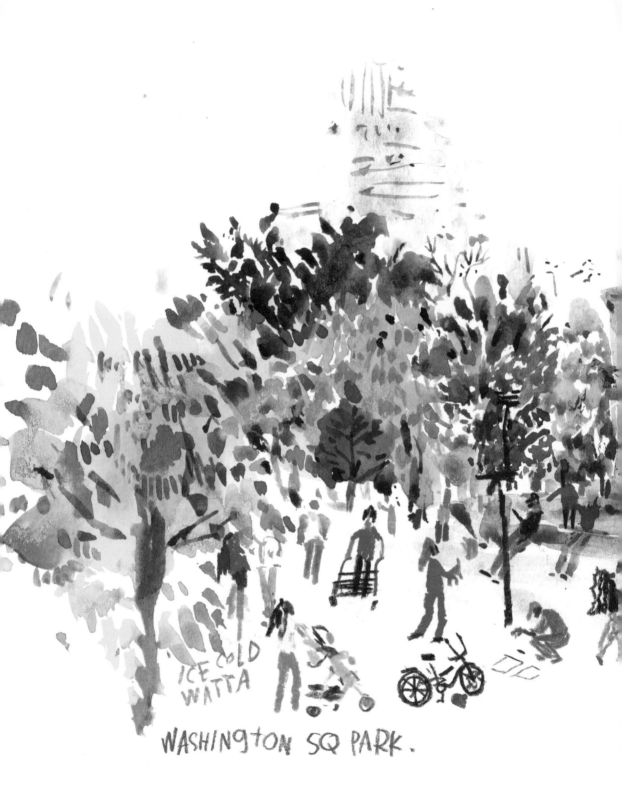

ICE COLD
WATTA

WASHINGTON SQ PARK.

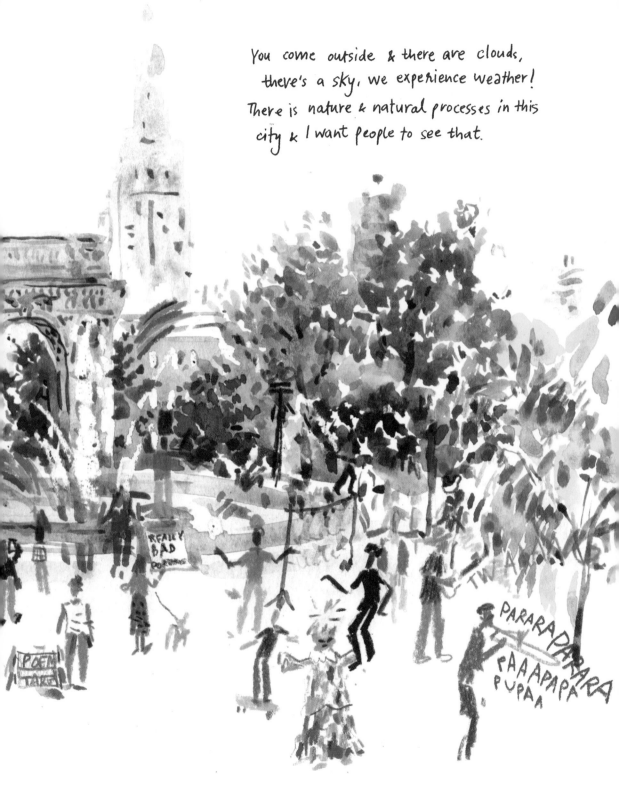

You come outside & there are clouds, there's a sky, we experience weather! There is nature & natural processes in this city & I want people to see that.

A trained urban forester, Georgia is the founder
of Local Nature Lab and director of Washington
Square Park Eco Projects, where she designs urban
ecology programs for New Yorkers of all ages. In her
own words, Georgia lives and breathes city trees.
She has been a neighbor of Washington Square Park
for over a decade and still feels like she has much
to learn from the 9.75 acres of the park. As someone
with a deep interest in trees, she set out to make
a tree map of the park in 2013. Georgia partnered
with Cathryn Swan, who writes the Washington
Square Park Blog, and then campaigned to raise
money and hire a GIS (Geographic Information
Systems) developer. Over time, Georgia realized that
there was much more happening in the park, and
what was once Washington Square Ecology was
renamed Washington Square Park Eco Projects.
It is their mission to monitor biodiversity, provide
environmental education and community science
programs, and advocate for the ecological health
of Washington Square Park.

I was born in Jamaica and lived there till I was
a tween. I grew up in nature—not like national park
nature or even rural nature. It was suburban nature.
Most of the trees in our backyard were edible fruiting
trees, and if you were hungry and the mangoes were
ripe you would just pick a mango. You could eat
from your backyard.

It seemed normal, it didn't seem unique or
special because that was just how everyone we knew
was growing up. You lived so much of your life outside
and outside wasn't necessarily hardscape. It was only
when I moved to the US and got older that I came
to realize that not everyone had the childhood I had.
To be able to go outside and feel safe, or to not even
think about feeling safe and to not worry about what
it means to be outside—it was definitely a privilege
to have that childhood.

Living here is different. We live in an apartment,
and in order to get outside you have to go through a
hallway, get in the elevator, and go out of the building.
It's shared and it's open. My kids and I spend a lot
of time outside and I don't talk about New York City
as being a place that is not natural, or a place that
lacks nature. I have tried to share with them a way of
looking for trees, plants, and animals.

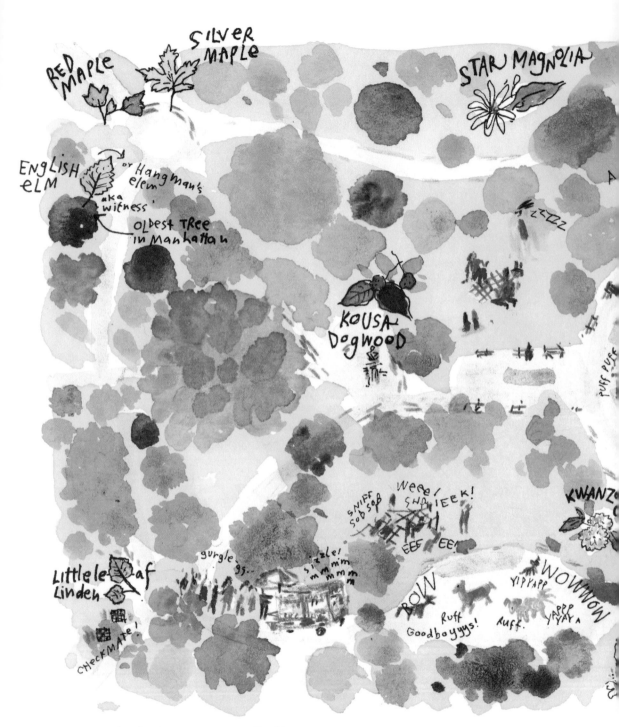

WASHINGTON SQUARE PARK

GEORGIA SILVERA SEAMANS

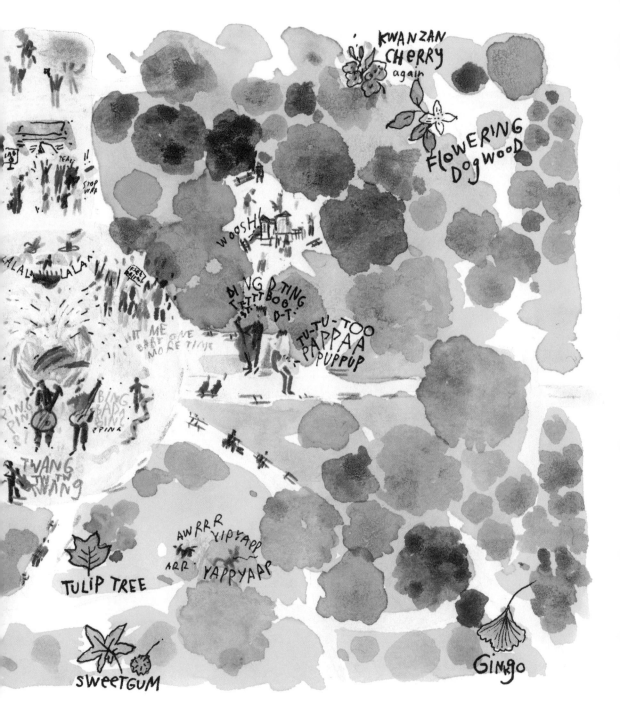

TREES BASED on the WASHINGTON SQUARE Park ECO MAP

FLOWERING DOGWOOD

STAR MAGNOLIA BUD SEQUENCE

EUROPEAN BEECH BUD BURST SEQUENCE

TULIP TREE LEAF TULIP TREE BUD TULIP TREE FLOWER TULIPTREE FRUIT

I feel that I know this park very well. It would be easy to say that it feels like my backyard but that feels like claiming ownership of the park. It's not really my yard. It's a public space, but because I spend so much time in the park I can say that I know it well.

I know the trees in the park. I know when the buds will start to open in the spring, when leaves and flowers will first emerge, and when fruiting will happen. I know the parts of the park where you can look for certain species of birds during the migration season—in the fall and in the spring—and that comes from spending a lot of time in the park. That's the way that this park has become known to me with repeated interaction over time.

KWANZAN CHERRY

RED MAPLE

KATSURA TREE

YOSHINO CHERRY

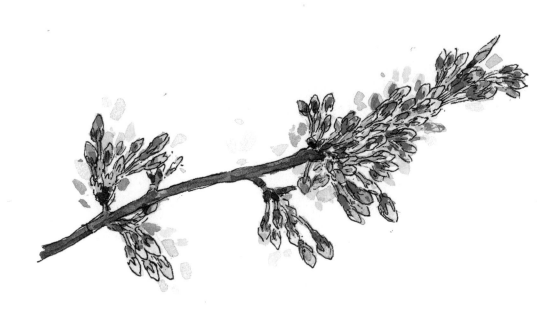

In anticipation of the bloom, dont overlook
the beauty of the closed flower.

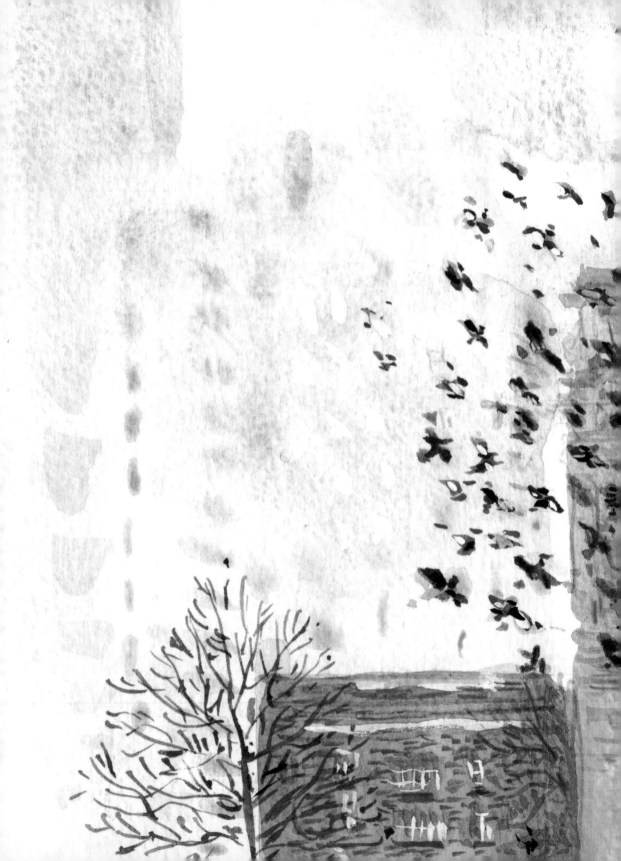

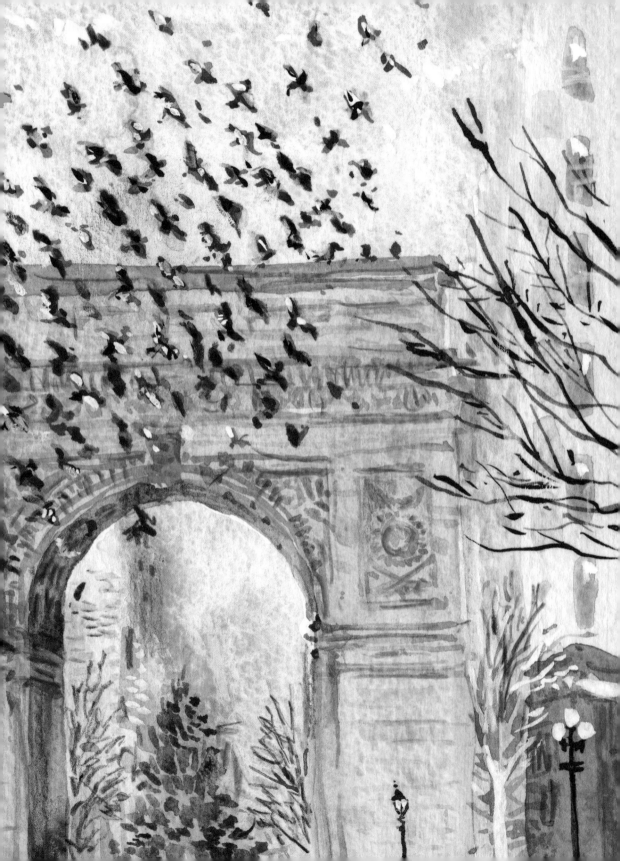

BIRDS of WASHINGTON SQUARE PARK

COOPER'S HAWK

COMMON YELLOWTHROAT

BLUE JAY

HOUSE SPARROW

WILSON'S WARBLER

YELLOW BELLIED SAPSUCKER

AMERICAN ROBIN

RED TAILED HAWK

GEORGIA SILVERA SEAMANS

Birds have been flying through this landscape for ages, long before Europeans created what we call New York City. This is THEIR landscape. Im living in it & as a visitor, & I want to show RESPECT.

Walking through the park in those early days, I noticed the birds and became very curious about them. I could identify pigeons, house sparrows, starlings, jays, robins, cardinals—the more common birds—but there were all these other birds I was seeing that I had no idea about. If I was committed to this project of becoming as literate as I could about this landscape, I knew that I had to find out more about birds.

In the birding world people talk about their patch, the place you go most often to look for birds. I consider this park my patch and I really don't twitch. "Twitching" is a birding term: when you hear about a rare or unusual bird in the city, you go to that place to check your list or get a photo. I don't do that. I just wait for the spring and fall migration, partly because I don't know how to confidently ID every species of warbler that you can see in this park in a year.

There's still so much to learn within these 9.75 acres. It's my patch and I want to know as much about it as there is to know about it.

A lot of the work that Eco Projects does, especially in the last several years, is really bird focused, but I am still a tree person at heart. Trees tend to be the backdrop to life, and attention is not necessarily given to the individual trees in the landscape. We might focus on trees in fall when there is fall color or in the spring when there are big flowers. When I share my writings, feelings, and photographs, I am foregrounding trees. I'm going to show you the different characteristics of these organisms, because they have this rich life and we're only seeing a part of it because we can't see what's happening on the inside.

They might not be as charismatic as warblers, and you might only think about them when they're in bloom or in the fall, but trees are still here other times of year. They are just there doing their thing and the thing that they're doing is keeping us alive. That's worthy of much more consistent attention.

There's the English elm in the corner, which is a super special tree. It is the biggest and oldest tree in Manhattan. It is more than 350 years old.

In the winter of 2020–21, I did a project with this group called the Environmental Performance Agency. You chose a tree and wrote a journal entry based on an engagement you had with the tree. Then you shared it with people, and people responded. I had been spending time with the old English elm and named it "Witness," partly because a tree of this age has witnessed so much history. It's also an environmental witness because, in the wood, you can read the environmental conditions that have happened over time. I would come and stand and wonder about what the tree was experiencing at that moment. Did Witness notice my presence?

I don't know what any of that really means. Birds notice your presence, and there's all this research that talks about the decision-making abilities of trees and their sensitivity to things in their environment. I'm just curious if that includes sensitivity to human presence. It's just nice to stand and look up. How fortunate to be able to grow so big and tall and old.

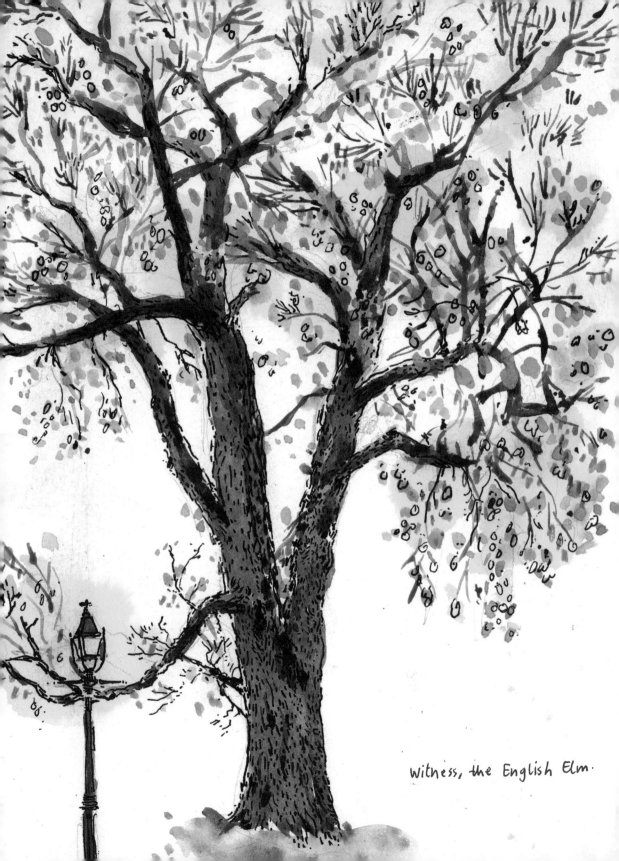

Witness, the English Elm.

I think it's important to know about the ecology of where you live.

There is so much of the ecology of the park that's changed over time. Some of the abrupt changes happened with Dutch colonization, then later British colonization, and then the park has gone through many design changes.

This park has the ecology that we can see, but also ecologies that we've razed and are hidden. I like the idea of learning about that and being able to share what I learn, and hopefully some of that will be able to reemerge or somehow be showcased on the landscape.

Climate change is a global challenge, so is biodiversity loss. I can't act globally, I'm one person, but I can certainly learn about what's happening right outside my door. Every place matters. The street tree outside my apartment matters, and this park matters even though it's just 9.75 acres. If we don't treasure these green spaces no matter how small they are, then it's so easy for these places to be lost.

Can you imagine if we started saying oh, well, it's so small, like, what does it matter? But it does matter. One way we don't undervalue these spaces is by learning as much as we can about them so that we are able to stand up for them when they're threatened.

I come and I have a notebook and I take notes and I take photos but that might not be your way. When we try to prescribe things to people and if that prescription is not accessible for someone, they feel that this thing is not for them. I don't want the way that I interact with nature to leave anyone out, because we all have our different ways of feeling comfortable.

Maybe you're looking out your window while you're drinking your coffee. You can do that for five minutes. You don't even have to write anything down or record anything. But just the fact that you're looking at that window, I bet if you look out the window and there's a tree or maybe there are some pigeons on a building ledge, over the course of the year you will notice that things change. Maybe you walk by a tree on your way to work, or school, or as you walk through the park. It's just really taking the time to focus on one tree or a grove of trees and however it feels comfortable for you to record that to keep that memory. That's the strategy or the tool you should use.

City planning as a profession gives you responsibility, and at the same time it also gives you power. You are able to make policies and decisions to improve a space.

JOSE LOPEZ

**Deputy Director of Parklands, New York City Department
of Parks & Recreation**

As you can tell, I am an avid lover of New York City's parks. Going for
a walk in a park is one of the easiest ways to get out of a funk for me.
My initial impression of New York was that it's rushed, intense, frantic—
which it is, but it isn't just that. During my first summer in the city, I started
going to Riverside Park every evening, and this became my time to relax
and reflect. I noticed that despite the intensity of the city, people seemed
happier, livelier, and more approachable in the park.

 Every park in New York feels different. Riverside Park, with its long
and straightforward path, offers a respite from decision making—you only
walk up or down, and it's easy to get lost in your thoughts. Central Park
is its own world and is often very social and buzzing with people. I credit
the curvy, winding paths for leading me to new discoveries in the park,
though one must be alert for the zipping cyclists, determined runners,
and the trotting horse carriages. Prospect Park is vast and social but less
manicured. It has hidden creeks and wonderfully wild trees and places to
sit by water, hidden among tall grasses. Washington Square Park, of course,
is a party. Four Freedoms Park is minimal and expansive, poised in the
East River between Manhattan and Queens. The little community garden
near my home is a maze of beautiful and lush green pockets and nooks to
hide in. Each park has its own distinct personality. I have often wondered
what goes into building a park and what it is like to watch it evolve as
a physical and social landscape.

 I met Jose Lopez, who is the deputy director of parklands in New York
City, for a morning stroll at his neighborhood park, Juniper Valley Park in
Queens. We walked through a buzzing park—Zumba classes, bocce players,
kids' tennis lessons, dog walkers, and birthday parties—and spoke about
Jose's experiences with nature and city planning.

If you look at nature & you spend
enough time observing & trying to
understand its mysteries,
it comes down to a relationship.

Just like how we're in a relationship
with any kind of person, & then once
you start seeing and listening,
you are going to find
guidance & inspiration.

Sunday, 9AM at JUNIPER Valley PARK

I like coming here, talking to the locals, and just asking them,
"Why do you come here every morning, what does it mean to you?"

It's a chilly day but you see so many people of different ages. They just use the park, and they have that relationship with the environment, whether they're running, playing a sport, or just sitting on a bench with the sun shining on them. These things are almost free. It is a gift that has been given to us that we have to preserve.

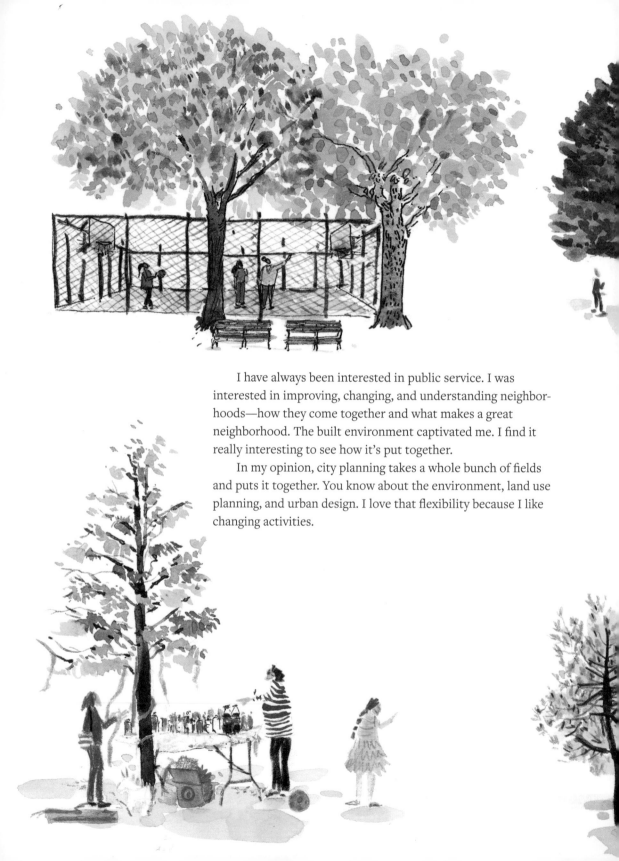

I have always been interested in public service. I was interested in improving, changing, and understanding neighborhoods—how they come together and what makes a great neighborhood. The built environment captivated me. I find it really interesting to see how it's put together.

In my opinion, city planning takes a whole bunch of fields and puts it together. You know about the environment, land use planning, and urban design. I love that flexibility because I like changing activities.

I see a city planner as being a doctor for the city. You want a healthy city, and you do that by creating elements like trees and great transportation. That is just one part, and sometimes we don't focus on the most important element, which is humans. You have to build to suit the needs of the people that are living and using the neighborhood. You acquire a piece of land, and the end goal is for it to become a park. It could take years in the making but when you drive by or walk by and see a bunch of kids enjoying that space, it's very gratifying.

> *Trees outlive us time after time.*
> *We have to give them the value & respect*
> *that they deserve.*

Professionally, I work on acquisition of parklands for the city. I am also in charge of protecting parklands from encroachments and misuse. I maintain the public records of the two-thousand-plus properties that the city has as parks.

I am lucky to work for the parks department and I work at Central Park. I used to work in Flushing Meadows Corona Park, which was also a park setting. You need money, but this job is not about the money. Just being in a park and being able to see trees has tremendous value for me at a personal level.

I do a lot of office work, but I need to be outdoors when there is a property that we need to analyze in terms of its value as an open space and as a recreational space.

When I am analyzing spaces professionally, I usually think about preservation. By preservation, I mean preserving open spaces. If we can preserve a space as a green space with some trees, I think we have achieved our purpose. It also depends on the need in a neighborhood. Any space has value in itself, so my approach is flexible; I don't believe in having a check-list. I allow the environment to speak for itself. For example, with climate change, if you know that an area is prone to flooding, then you don't want to put a basketball court there; maybe you can leave it as a wetland or a natural space like a bioswale to catch water.

You need different kinds of open spaces. Having a basketball court or a tennis court is important, but you can also have trees around it. You need to have a mix. You also want to have relaxing and passive spaces where you can just walk and listen to the music of the trees and the wind.

We have small parks in the city. A small triangle of green still serves a purpose. I might plant a tree now and I might not see that tree grow. I might be gone, but I'm hoping that the tree will grow to be eighty years old.

Sunshine preservation should be at the forefront of development, especially in cities.

In an urban environment, there are so many kinds of interests that some level of conflict is inevitable. In the case of real estate development, if you build skyscrapers, they can take away the sunlight during certain times of day. Most plants need four to six hours of sunlight, but by building tall buildings, plants in the shadow areas will get less sunlight, especially in the winter months.

If you take sunlight away from the parks, all the flora will be impacted. The effects may not be apparent right away, but over the years you might see that taking away two to three hours of sunlight could kill an established tree.

This doesn't just apply to plants; humans also need sunlight for their well-being. When I moved here, it took me a long while to understand and get used to daylight saving with its shorter winter days. Having open spaces and parks, especially in a place like NYC where you don't have that much free space or a backyard, is so important. I hope people understand and start taking better care of their spaces.

Shadows of the Billionaires' Row on Central Park

Time is a commodity. People have to make nature a priority, but for people who have less time and less resources, it's just not going to happen. Who has access to nature and who gets to enjoy it? If you are worried about putting food on the table or if your rent is due, you can't just walk and look at trees when you have to pay your bills.

We all have different amounts of resources, different responsibilities, and different amounts of time, that's what it comes down to. You also have to define access. Most people think of access as being able to open your door and walk into a park. But if there is no park in an area, and there is a need for open space, we look into it and identify possible resources to acquire additional land. If you're not able to acquire land, then can we have a free bus on weekends?

A big part of it is improving and working with what we already have. You can take from the earth, but you have to give back. Do your part, keep it clean. Nothing special. Being a part of society we have a responsibility toward ourselves, the spaces we have, and the planet.

Florists should be at the forefront of building a framework that fights against climate collapse because we take so much from the natural world.

ALEX CROWDER
Florist, Brooklyn

During the New York City climate strike on September 20, 2019, I saw these banners, "Florists for Climate Justice," "Florists against Climate Collapse!" and was immediately intrigued. It was there that I met Alex Crowder, a self-taught florist from Missouri who is now based in New York. We exchanged details and a few weeks later Alex introduced me to the flower district in Manhattan.

"Feel free to talk to the plants, they understand," says a sign on the top floor of the Dutch Flower Line, a shop where Alex often gets her flowers. Between 6th and 7th Avenue on 28th Street, New York's flower district is a spot of color among the city's usual grays. I was thrown into a world of color as I entered the shops lining the street. Delicate peaches, deep magentas, and royal purples bloomed amid burgeoning buds. Tulips from Holland, proteas from South Africa, and roses from Ecuador. Alex has been coming to this market for the last five years. She told me what it takes for an exotic flower to reach the flower market in the city—several flights, refrigeration, sprayed-on chemicals, and a massive carbon footprint.

When I first interviewed Alex back in 2019, she was working as a freelance floral designer with a mission to change the industry from within. In the first year of the COVID-19 pandemic, Alex founded her studio, Field Studies Flora. Named after the literal study of the field, her practice aims to study both a field of flowers and floristry as a field. It was Alex's way of getting flowers to the people without relying on events or any in-person gatherings, which in 2020 and part of 2021 were not happening. The flower deliveries were composed of local and seasonal flowers, and she used the studio website and social media as a means of explaining where the flowers were coming from and detailing facts about their names or botanical significance. Alex is now back to events and on-site installations; everything she uses is from local farms or foragers and she loves teaching her clients about the fields where their flowers came from. Her hope is to be one of many who will be a part of rebuilding the floral industry, and in so doing, fight for climate and civil justice.

DRAWN LIVE AT THE climate strike Protest

WHERE ARE THESE
Balloons gonna go?

SAVE
OUR
PLANET

IT'S
BIO
DEGRAD
ABLE

POLAR BEARS
NOT PROFITS

HEY HEY
HO- HO
CLIMATE
CHANGE HAS
GOT TO GO

DARE TO
BE A FORCE
OF
NATURE

DONT KILL IT
JUST CHILL IT

WHO
HAS
THE
RIGHT
TO BREATHE !

YOLO

YOLO

YOLO

STOP
POLLU-
TION

FIX OUR
PLANET

SAVE OUR
PLANET

SCIENCE
IS NOT
FAKE
NEWS

GREEN IVY
SCHOOL
GRADES 3-6.

Our livelihood depends on the natural world,
& to not have a reciprocal relationship
with it strikes me as odd, because
at some point, it will run out.

CLIMATE
STRIKE
20th SEPT, 19
NYC.

FLORISTS
AGAINST
CLIMATE
COLLAPSE

FLORIST 4
CLIMATE
JUSTICE

ALEX
W CROWDER
(florist)

PROTECT
PEOPLE
NOT
BORDERS

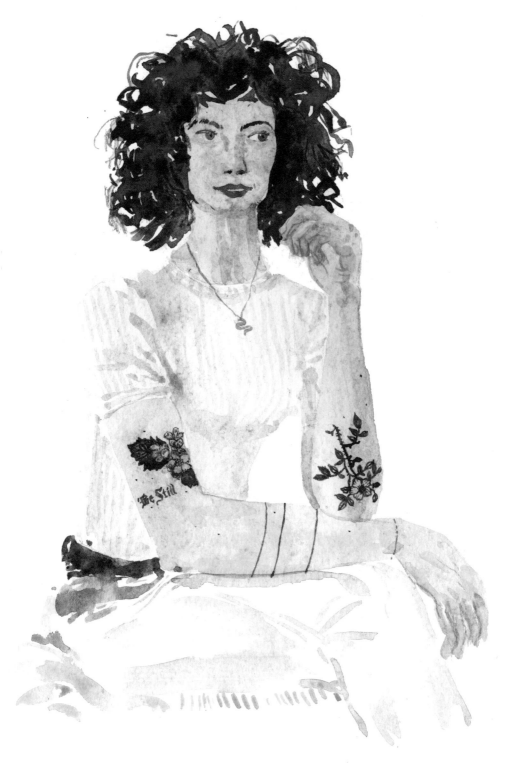

I grew up in Missouri. I was always in the weeds and in the plants as a kid. My grandfather had a farm, my mother always had gardens, and so I used to love playing with flowers. An embarrassing incident early in my childhood, where I uprooted plants in my dad's boss's home garden, taught me that I could cut flowers nicely rather than destroying the entire plant (my dad's boss and his wife were quite nice about it!). I continued to play with flowers, and I used to leave my mom little arrangements around the house. From that point on, flowers made their way into all aspects of my life. I ended up going to school for graphic design where a lot of my designs were covered in flowers.

I was recently back in Missouri, playing in the woods for a job that I was working on, and my mom said, "It's so lucky and so wonderful that you are now doing what you did as a kid—you played in the woods and now it's what you do for a living." That was a very lovely idea, and I hadn't thought of it that way.

After graduation, I was hired by Anthropologie to do their window displays, and I always put flowers in them. Over the years I have come to specialize in installations and set-design jobs centered around flowers. I freelance for a lot of different people, and I really enjoy it. This year I committed to myself that I was only going to work with people who I can learn from. I'm trying to strike out on my own as much as possible, which is really exciting, but I have very strict rules and ideas about what I want that to be. I only want to use local seasonal foliage.

I'm really excited to work my own way, but I also feel like I sometimes wall myself in. The floral industry has great room to grow in a more reciprocal and sustainable way, but it's just not there yet.

A few of Alex's favorite things

State flowers are chosen differently for each state in the US. In New York, school children were asked to vote, they picked a rose. What kind of rose was unspecified, so I picked a wild rose. In Missouri, my home state, there was a vote & the legislature picked Hawthorne. I found these images in a vintage book & referenced them for my tattoos.

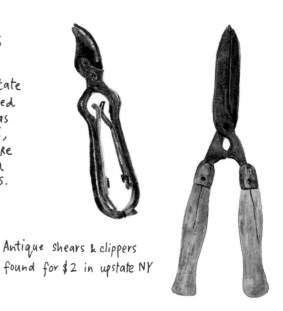

Antique shears & clippers found for $2 in upstate NY

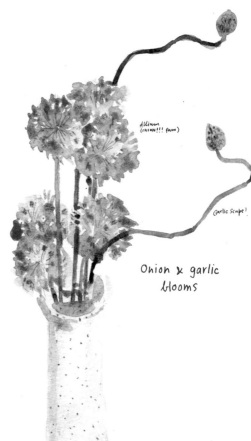

Allium (ONION!!! farm)

Garlic Scape!

Onion & garlic blooms

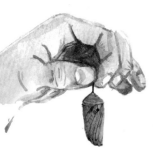

MONARCH Butterfly CHRYSALIS

I found this chrysalis on a branch that I accidentally clipped. It looked like a jewel hanging off the branches & I was so sad that she didn't make it.

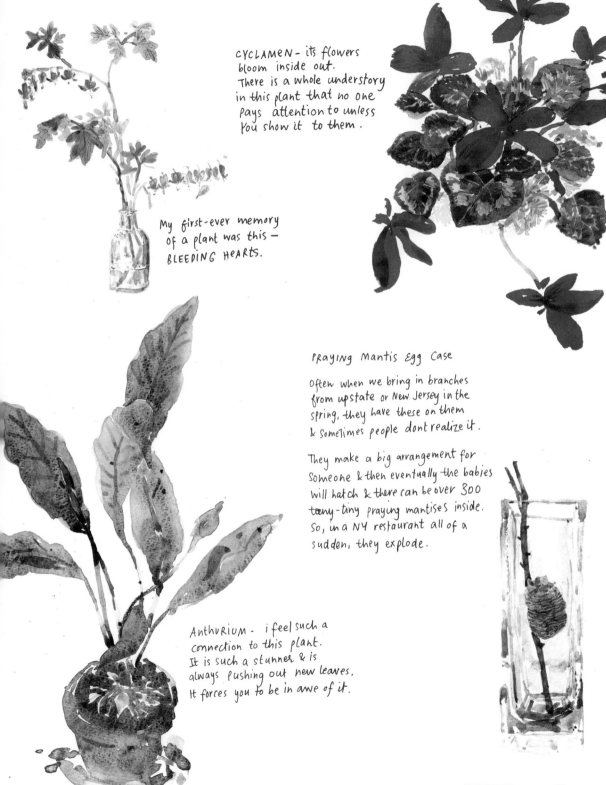

CYCLAMEN - its flowers bloom inside out. There is a whole understory in this plant that no one pays attention to unless you show it to them.

My first-ever memory of a plant was this — BLEEDING HEARTS.

PRAYING Mantis Egg Case

Often when we bring in branches from upstate or New Jersey in the spring, they have these on them & sometimes people don't realize it.

They make a big arrangement for someone & then eventually the babies will hatch & there can be over 300 teeny-tiny praying mantises inside. So, in a NY restaurant all of a sudden, they explode.

ANThURIUM - i feel such a connection to this plant. It is such a stunner & is always pushing out new leaves. It forces you to be in awe of it.

I've always been involved in different social justice movements. I am interested in the voices that are present at the table, and I recognize that because of my status (as a white woman), especially in the United States, that I have a platform that's not given to other people. There are communities that are largely affected by this job that I love, and I wonder how I can affect change.

So much of this effort to make change is about teaching people where their flowers are coming from and why it matters. I think the farm-to-table movement and the food industry did a really good job of teaching people where their food is coming from and why it was good to buy local and seasonal, not only for themselves but for their community. Flowers need to have a similar movement, a way of doing that is teaching people about the flowers that are available in their vicinity.

Flower district, Chelsea.

TROPI

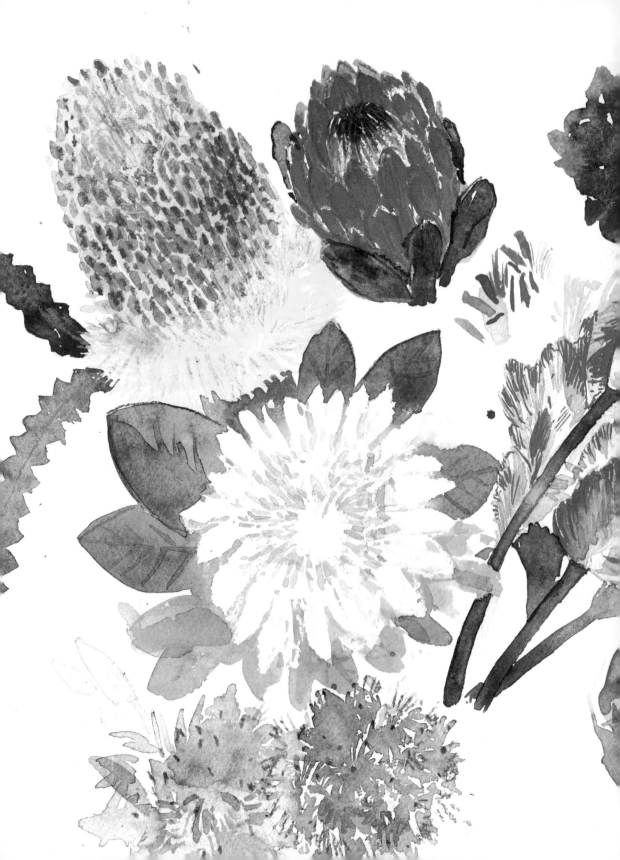

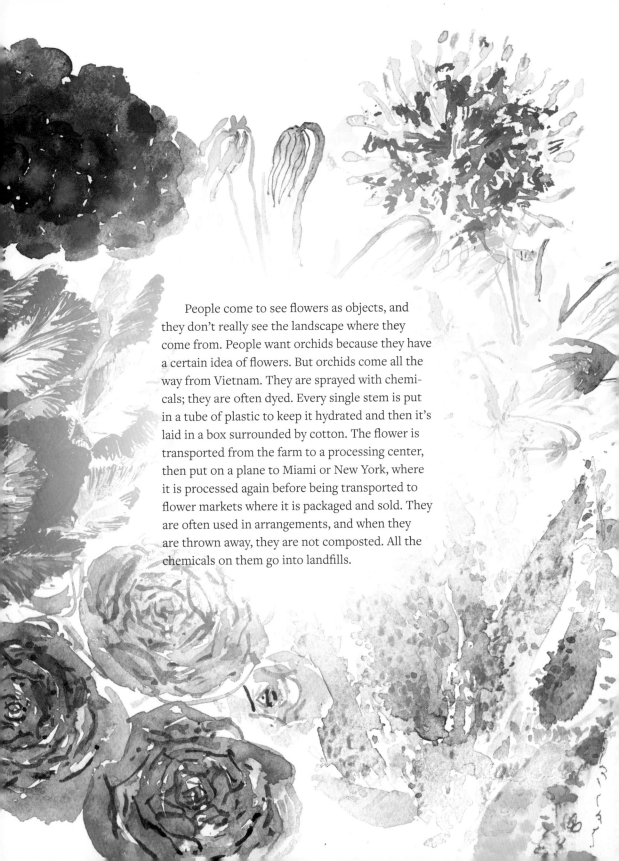

People come to see flowers as objects, and they don't really see the landscape where they come from. People want orchids because they have a certain idea of flowers. But orchids come all the way from Vietnam. They are sprayed with chemicals; they are often dyed. Every single stem is put in a tube of plastic to keep it hydrated and then it's laid in a box surrounded by cotton. The flower is transported from the farm to a processing center, then put on a plane to Miami or New York, where it is processed again before being transported to flower markets where it is packaged and sold. They are often used in arrangements, and when they are thrown away, they are not composted. All the chemicals on them go into landfills.

There are days when I struggle to make sense of why I am in an industry that can be so wasteful, but I also see the impact I'm having just by talking to people about it, something I can do only because I am a part of this industry.

Cutting flowers and giving flowers to people isn't bad, it's actually good for the plant. It's like a haircut—you're not uprooting the plant. It gets harmful when you grow the same crop in the same part of the land over and over again, while infusing it with chemicals. Giving flowers has always been a way that we humans have expressed emotion toward each other. We've always been drawn to them, whether it's for sustenance, beauty, or the fragrance. It seems that we are not that different from a butterfly attracted to a flower. We just have the strength and the ability to take them. I think that if you can make people see a flower in a different way, then you can inspire not only admiration for that object but also a sense of respect, and then people are more likely to take care of something.

I use my skills to elevate local or seasonal flowers or weeds and get people to see them in a new way. This is my livelihood. I am really good at this. I also want to fight for change. I think we put this idea of activism into a small box. I am incredibly thankful for social workers and people who put their lives on the line, we really need them, but you can infuse activism in your work ethic as well. You are doing it as part of making this book, and I have the opportunity to show this beauty that I grew up with to people, especially in the city. I am from where I am from. I grew up in the woods, and I feel such a connection to it. I'm always cognizant of where this plant came from. The fact that it can and will run out unless you do something is my drive to fight against climate collapse and fight for climate justice.

I am from where I am from.
I grew up in the woods, &
I feel such a connection to it.

Touch these shoots, so tender
SNIP, SNIP, SNIP
Feel the leaves. How soft.
Rub this branch.
SMELL how spicy it is.
Listen to the buds falling in the container.
PLiNK. PLONK. PLiNK.

TAMA MATSUOKA WONG

Forager, New Jersey

With Tama Matsuoka Wong, foraging is all about touching, smelling, looking, and feeling.

I visited Tama at the New Jersey Audubon Wattles Stewardship Center, where she often forages with permission, and spent the morning ankle deep in a mat of celandine, an invasive plant whose buds Tama is foraging to send to a restaurant in New York.

There is a history of foraging everywhere. For Tama, foraging is a cultural experience. When her father visited her from Japan with some friends, they were thrilled to see *hakobe* (chickweed) in the meadow in her backyard. For others in the locality this was just a weed, but in Japan it is one of the seven precious herbs of spring. Dead nettle, which sounds unappealing, is not even a nettle, and is called *odoriko-so* (the dancing lady's hat) in Japan because of the way the plant looks and moves in the wind. To Tama, these differing names are representative of the feeling associated with these weeds in their cultural contexts. It shows that they are respected and cared for in Japan.

As part of her journey to understand and know every plant in her meadow, she started identifying and cooking with edible weeds. Edible, however, does not always mean delicious. With the desire to create delicious food with the plants in her backyard, Tama collaborated with Eddy Leroux, the executive chef at Daniel in New York City. Tama brought foraged plants to Eddy, who then experimented and came up with recipes. Together they wrote a book called *Foraged Flavor*, which came out in 2012.

Tama was not always a forager—after twenty-five years as a financial services lawyer, foraging and working with people in the plant and food community became a never-ending creative endeavor. Tama started getting known locally for her meadow and weeds, and in 2009 she started her own business, Meadows and More. With the field as their office, Tama and her team worked with close collaborators to explore the look, feel, and taste of wild plants. They harvest plants, seasonally and sustainably, to supply local restaurants.

A morning spent with Tama was an explosion for all the senses, and I invite you to look at the plants around you through Tama's lens.

There is something about knowing exactly how, where & when your food came from.

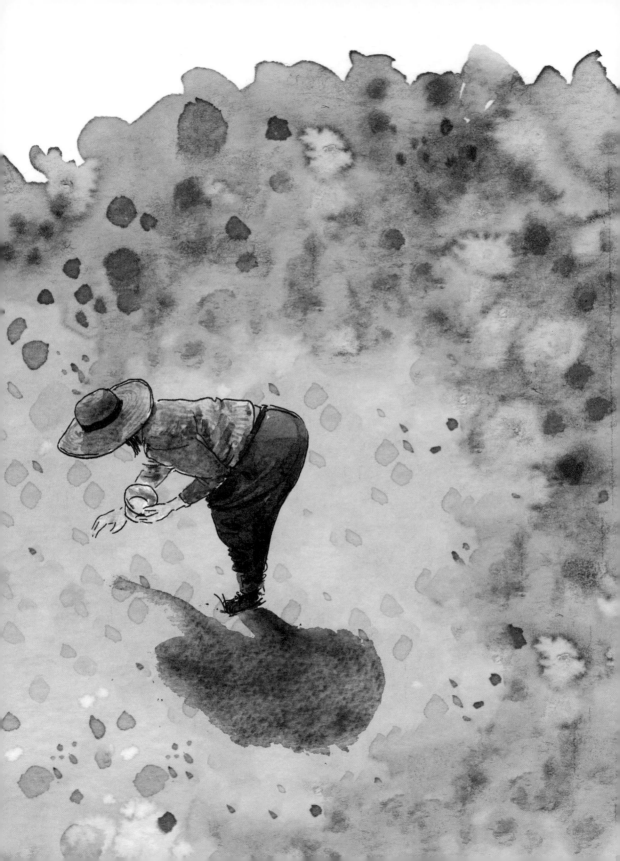

A lot of the plants I forage are introduced from someplace else. They are invasive weeds that get out into natural areas & can upset the balance of biodiversity. You can't really eradicate them. I am not a very good cultivator but the thing about invasive plants is that I don't need to grow them. They are just there.

TODAY, I AM FORAGING CELANDINE BUDS FOR A RESTAURANT that will PROBABLY PICKLE tHeM like CAPERS.

Right now, these leaves look too MATURE. They are too WAXY & the toxicity in them increases as they grow and it tastes too Sharp.
I pick them when they are really young.

When we came here in the morning, we struggled to find buds. But as the day progresses, they start to shoot up & we can see more. We are almost seeing them grow.

WHEN I PICK the BUDS, I tRy Not to have the STEMS ON.

Nothing's ever too tINy.

I AVoid picking BUDS when they start to open.

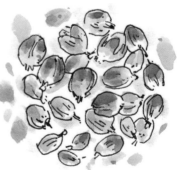

It's this tiny little window in time. You are there in the moment.

Every plant is a little different.
The way it grows, the parts you pick &
the point in time when you forage
— it's all about knowing how the plant grows.

Knowing a plant means knowing how it grows
in different seasons in different places,
because every place is different.
It's a process.

WHEN YOU are FORAGING, YOU are using your EYES, YOUR HANDS, YOU are SMELLING things, and

PLINK PLINK PLINK PLINK PLUNK PLUNK PLONK PLINK PLUNK PLONK PLINK PLUNK

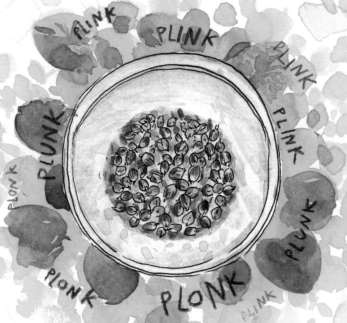

EXPERIENCING it for YOURSELF. it is HOLISTIC & MUCH DEEPER than iDENTIFYING A PLANT.

FEEL THE TEXTURES. SO SOFT.

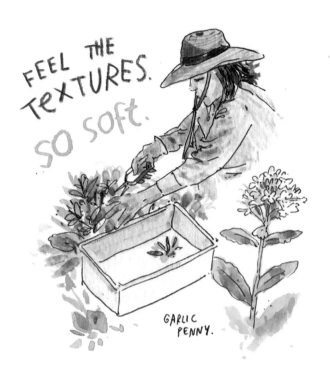

GARLIC PENNY.

wild foods are so much more interesting. If you go to the supermarket to buy lettuce or arugula, they feel so rough & everything tastes the same because it has been bred for yield & shelf life.

The owner of this land has been trying to get rid of these weeds, so there are slim pickings. Someone else has already foraged the main stem, but when you cut the main stem, it forces the plant to grow these tender side shoots.
It is time consuming to forage them, but it is still good stuff!

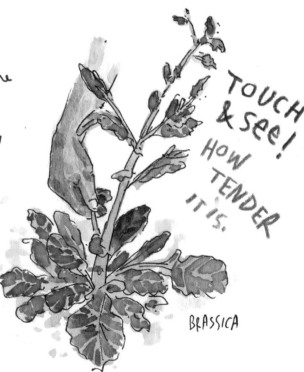

TOUCH & see! HOW TENDER IT IS.

BRASSICA

SNIP SNIP

SNIP - SNIP - SNIP

Sometimes it's so TENDER & it's easy to pull it by hand. Getting a scissor in there is hard when the plant gets unwieldy like this. Whereas, if you have a big piece that is accessible, it is easier to clip it with a scissor. It Depends on the FEEL of it.

When I'm here everything else just falls away.
Nothing is shouting. It's just there.

A lot of this is repetitive, but at the same time it's always interesting. It's repetitive and calming, but it is not monotonous. It is never the same.

You are not just walking around, your mind is focused, and you stop thinking of all the things that you would be thinking of or things that are bothering you, like the news, social media, people arguing, people shooting.

When I started working with chefs and restaurants, I met interesting people who wanted to create something with these plants. In a kitchen, there are a lot of different people there and they all bring things that they recognize from where they are.

This became a never-ending creative endeavor. Working and engaging with other people is a process of mutual learning. Not everybody knows everything, and in interacting with people from different cultures I learned about things that I wouldn't have thought of myself.

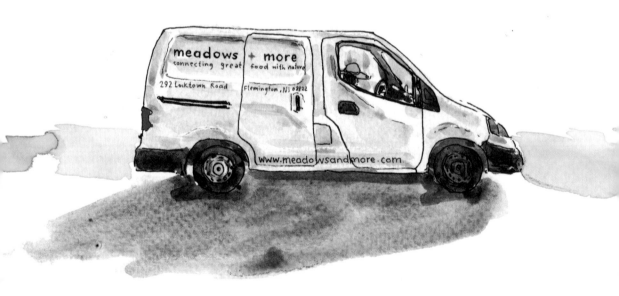

Plants & food are all about community.

If you are able to talk about these things
with each other or break bread or share rice
with someone, then it doesn't matter
if you are tall, short, old, young.

There is something you can connect on,
on a very human level,
beyond all the things that
divide us now.

Herbalism is about helping people
understand themselves as part of
a circle of life &
not separate from or above nature.

JESS TURNER
Herbalist, Brooklyn

If you had a cold or a persistent cough growing up in my household, before you called the doctor, my grandmother would already be preparing a *kadha*—an immunity-boosting concoction of various kitchen ingredients that I never bothered to acquaint myself with because, frankly, it tasted downright nasty. But the kadha always soothed my throat. Every household makes kadha differently. *Dadi ke nushke*, or grandma's remedies, are ubiquitous in most Indian households. Turmeric, ginger, and pepper for colds. A reduction of *ajwain* or caraway seeds boiled in water for my constant stomach aches. A *laung* or clove behind your tooth for a toothache.

I never questioned these practices or even thought of them as medicine—they simply existed as comforts alongside prescribed medication, and as I got older they were accompanied with a lecture on a deeper, slower lifestyle change. These remedies are made from simple ingredients found locally and are passed down through generations or shared by word of mouth with trusted friends and relatives.

These traditions of care and healing differ across geographies and ethnicities, and I was curious to know about herbalism and what it looks like for someone practicing in New York. I met with Jess Turner, a Black clinical and community herbalist whose practice is centered on helping low-income BIPOC communities repair through connection to the land and plants growing around them. Jess is also the founder of Olamina Botanicals, a bioregional apothecary crafting tinctures, tonics, syrups, and salves in Munsee Lenape territory, Brooklyn, New York.

Homemade Sauerkraut

Beet + GINGER + CARROT

GLASS
JAR
to weigh
Down the
mixture

I went into social justice & activism from the perspective that I want to make the world a better place.

Growing up, I saw my mom and my grandmother always doing things for people, supporting people, and showing them that they cared, and often that support came in the form of a home-cooked meal.

I was involved in political organizing and labor-union work in college, and after college I worked as an organizer. When I was campaigning, I saw myself as someone who was helping empower marginalized people build a revolution of the working class. That was the foremost concern. My body and my mental health were just not on the table. I was also a publicist at a Marxist press before I started farming and it was intellectually very rigorous. I could go an entire workday, which was very often ten hours or more, just sitting at a computer, only moving to get up to use the restroom or to eat.

As I reached the point of burnout, I realized that I have been doing all of this stuff for "the world," but where has it left me? I started thinking back and reflecting on what things made me feel best. What made me feel grounded? What made me feel most in my body? It was the experiences that I had with plants as a child.

I no longer felt like some automaton living & working in a box.

I am conscious of myself as a living breathing organism. as an animal who has a role to play in the ecosystem of where I am.

I left my job to go work at a farm in Hawaii. When I started working with plants professionally, what felt good was feeling connected to the web of life. I would often do my work without gloves. So when I was working with soil, I would touch the soil. I remember the first time that I took my shoes off and the feeling of my feet on the bare ground.

I had an intellectual understanding of climate change and how petro-colonial capitalism had brought our societies to the edge, but having a more heart-centered connection to the rest of the life forms on Earth, that was something that was missing.

I think of my role as an herbalist as being a person who helps people connect with and build relationships with the plants that they are supposed to walk with on planet Earth in this lifetime.

It is not just addressing disease with herbs but helping people reach homeostasis, helping people be as vital as possible, helping people trust and support the vital force in their body, which wants them to be well, grounded, and happy.

My most favorite part of my herbalism practise is getting other people excited & enlivened by the plant WORLD. Part of this process of helping people feel ownership over the struggle that we need to engage in on behalf of the planet is building Relationships & tapping into the stories of these plants.

BLUE vervain - for the rigid type, for an anxious perfectionist with tight shoulders & for someone who has difficulty letting things go.

ELECAMPANE
ROOT

If asthma or anxiety shows up in your lungs Angelica or ELECAMPANE are expectorants that help to break up phlegm in the lungs. They are oily, very aromatic, and pungent & strengthen the respiratory system.

Angelica

GINGER is a warming circulatory tonic
& offers respiratory support.

For inflamed, hot & dry lungs, demulcent plants
are very useful. Demulcents are softening, moistening,
& cooling. They are found in mucilage - boiled okra,
nopal cactus, slimy foods like aloe vera, chia seeds in
water, flax seeds in water & in the medicinal realm,
marshmallow root.

DANDELION ROOT is slightly bitter & slightly sweet. For someone
with a weakness of conviction who struggles with trusting
themselves. For someone whose anxiety shows up in their
digestive system, dandelion is your plant ally.

Constricted chest & trouble
taking deep breaths?
MULLEIN is your friend.

JESS'S APOTHECARY

Living in a world where your worth is often judged by how much money you make, we are under so much pressure to be productive.

A big part of my practice is about getting people to think about what they're putting into their bodies. What are the bulk of your meals? How is your sleep? What other practices are you engaging in throughout the day to help process the things that you're experiencing?

I've definitely experienced folks who are resistant to making changes and perhaps that is in keeping with the western way where it is about a monetary exchange. I pay for this herb to do a certain thing. Why is it not doing it? People don't think about food as being healing, or how what they eat impacts them until they feel terrible. They want to be given something to change it, immediately.

Living under the systems that we do is challenging and traumatic for us all. It can feel like we're on a hamster wheel, especially in a place like New York City. Things have changed for me since I started practicing herbalism. Part of it was about wanting to do work where care of myself would be central, but even as an herbalist, knowing everything that I know, I still have moments where I'm like, wait a minute, wait a minute. Slow down.

"Once you learn to identify plants,
you will never be alone,
you will be surrounded by friends
everywhere you go."

— Dave Meesters, former teacher

One summer day, I was trying to figure out my next move, and feeling super sad. It was in the midst of a bunch of Black Lives Matter protests. When BLM initially kicked off, I was in Hawaii, far away from the people I know and care about, but on this particular day, I was walking in the southern end of Central Park. I looked up and I saw a grove of hawthorn trees. I wasn't sure that they were hawthorn, and I went over and I saw that they had five sepals and that the leaves were serrated. I saw a couple other things that let me know that these were hawthorn berries and I burst into tears.

I just started crying because hawthorn has been used for protection medicine, for heartbreak medicine, for grief, and for sorrow. I was in a place of mourning the state of the world, my desires for a more liberated world in contrast to the reality of where we're at in the United States, and feeling just scattered and all of those things. And here was this plant that is so deeply supportive to someone who is in the place that I am.

So, every time I see hawthorn, I don't cry, but I just feel giddy and I feel joyful. Helping people develop that type of relationship with plants and seeing the look on someone's face through some connection that we were able to help them make is pure joy.

The prison experience
is overwhelmingly
about LOSS. —

Loss of freedom
Loss of autonomy,
& loss of self.

STACY BURNETT

Alumni, Bard Prison Initiative, New York

As I was developing this book, I was curious to learn more about the therapeutic effect of nature. My research led me to a few organizations that work in the realm of horticultural therapy in prisons in the United States. I tried reaching out to several horticultural therapists and instructors, but it seemed like it was impossible to get in touch with people who were willing to share their experiences of working with horticulture in prisons.

I had almost given up, but then one day someone wrote to me saying that they had read my email and were interested in talking but could not officially record an interview. They shared a link to an online recording of a conference on Social and Ecological Infrastructure for Recidivism Reduction convened by Boston College and Yale School of the Environment. It was here that I learned of the Bard Prison Initiative (BPI). BPI is a college program that is reimagining who college is for and where it might lead. The BPI college is spread across six interconnected prisons in New York State. The program enrolls over three hundred students and organizes a host of extracurricular activities to replicate the breadth of college life and inquiry for incarcerated individuals. Recidivism refers to the tendency of those convicted of crimes to relapse or reoffend, and statistically, education is one of the most effective strategies to reduce recidivism.

With the aim of nurturing social, emotional, and ecological learning for the students, the Urban Farming and Sustainability program began at BPI in 2017. Jocelyn Apicello is the faculty advisor and I heard her speak at the conference along with alumni from the program. Through Jocelyn, I was able to connect with Stacy Burnett, one of the alumni from the program.

Stacy was at the Taconic Correctional Facility, which is a medium security level facility for females in upstate New York. Stacy focused on urban planning and public health during the program and shared her experience of working with horticulture during her time in prison. In the built and isolated environment of prison, gardening became a way to cultivate growth—in other living beings and in herself. She is a firm proponent of education within the prison system. Having an education enabled her to build a self-sufficient life for herself after release, and it was eye-opening to hear her experiences.

This was an unusual interview to draw. There is no documentation of the garden or the objects that Stacy shared during our conversation. Jocelyn found stock images of the actual objects that are mentioned, and I drew from those.

My involvement with gardening in prison with BPI was rife with lessons & symbolism that informs my work to this day.

> *There is not a lot of personal or emotional growth that happens in prison. It's not a place where anything really grows*

The Bard garden started the year before I joined. Everyone from the previous year had left—they had been released or sent to other facilities. So it was almost like starting from scratch. Nobody knew where the gooseberries went, nobody knew the optimal placement for the cantaloupe, we had to figure it all out. It's so much more complex than just dumping some seeds in the ground and seeing what happens. What we do dictates whether a plant makes it or not; I became personally invested in whether a scraggly tomato plant would survive.

So many of us are mothers and are not around our children. When you have all of this innate desire and capability to care for other things and other people and you're in a place where you can't do that…expressions of caring come with a significant risk, not from other prisoners, but from the administration.

In the garden, a lot of this intent and need could be addressed and filled, while still operating within this system that is by its nature oppressive and isolating.

To participate in a primal, natural process
like growing a tomato in an
unnatural environment like prison
shifts the equation — something beautiful
& essential is unfolding within the dust.

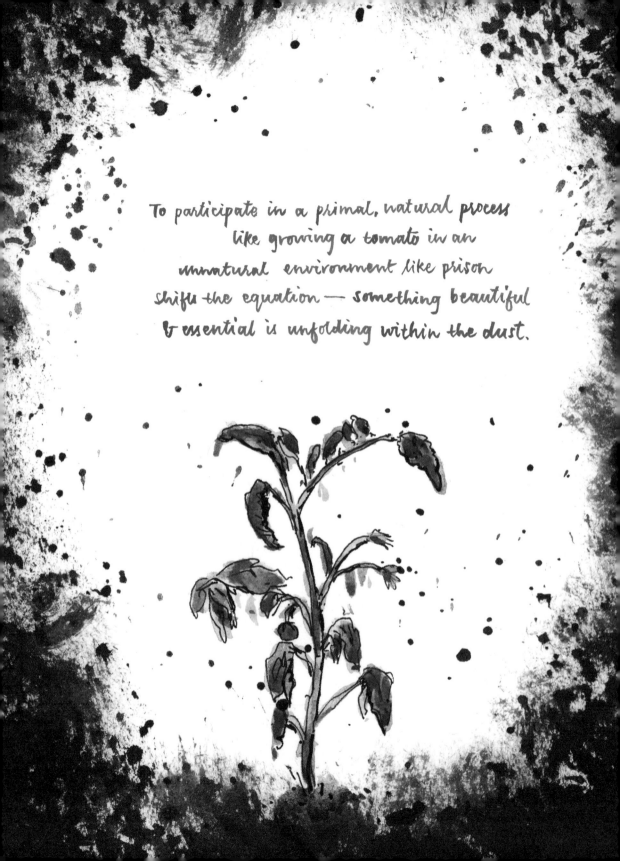

We often didn't have buckets to water the plants, so we went to our housing units, got mop buckets, and carried them back. We would carry seven gallons, which is almost fifty pounds, down the stairs and fill it up in a slop sink. Someone would bring a cup or a water bottle and use that to scoop water and water the plants.

We used to have to fight and cajole and try to figure out how we could go take care of our plants because a lot of guards are not sympathetic. They don't think we should have anything.

We weren't even supposed to be eating the stuff that came out of the garden. We can grow it, but we're not allowed to eat it, which is very common for prison garden programs.

Jocelyn made all the arrangements of getting the plants, seeds, and the approvals. This wasn't part of any curriculum. We didn't have rakes or shovels and we had to ask the maintenance department to bring them in. The maintenance sheds are not on the facility grounds because this equipment can be used as escape tools, and they do not want it in close proximity to incarcerated people. It practically took an act of congress to make this happen. While we waited for shovels, we started digging with our hands or whatever cups we had.

I never wore gloves in the garden, because the dirt under my nails was my proof that I was there, witnessing the rebirth of this small plot, and all the good that can come from the dirt. Dirt became soil as we worked it. I believe we were all healing in that transformation and found meaning in an inhospitable place.

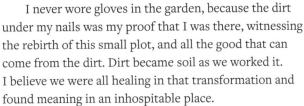

One of the most profound moments was when there were these tiny tomato plants that were fragile and probably not going to make it. The inmates had put them off to the side because we had very low expectations, but then Jocelyn said, "No, they need the best light, they need the most nutrients. We need to move them where they're going to get what they need."

That was a life changing moment for me because I felt like those little plants were really us.

We had already told ourselves where we weren't meant to be and gave ourselves very low expectations of succeeding in anything.

With the right sun, the right soil, and the right companion plants alongside them, they caught up and were just as robust as the ones that had a much more auspicious beginning. They just needed a little bit extra and somebody who knew what they needed to be successful and do what tomato plants are meant to do. They just needed the right place and it felt like a parable for who we are, where we are, and that we just need that little extra bit so that we can do what we are meant to be doing.

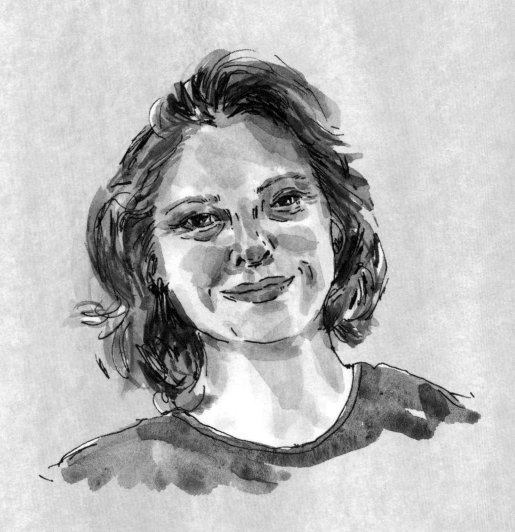

This deep connection to the outdoors has always been part of my family & they passed it down to me. It was a part of me before I was me.

Yvette Weaver

Horticulturist, New York and New Jersey

Yvette is a horticulturist who has studied at the New York Botanical Garden and worked at Fort Tryon Park, Wave Hill, the Met Cloisters, City Green Farm Eco-Center in Clifton, New Jersey, and most recently at the High Line.

From the sweeping views of the Hudson River at the Cloisters to serene sunsets over the water from the High Line, the river has always been a part of Yvette's journey with plants. I connected with Yvette during her last week at the Cloisters, then met with her at City Green Farm and also at the High Line. The conversations I had with her were less about the institutions where she worked than about her love for working in public gardens. What we connected most about was family.

Amid tangled weeds and blooming asters, we spoke about family, nature, passion, and rest. In hearing her memory of her aunt who gave her a love of living, growing food, and eating well, I also missed my aunt who lives thousands of kilometers away and had transformed a rooftop in an industrial area to a garden and filled my childhood with an appreciation for trees, gardens, and birds. Our aunts didn't just introduce us to nature, they introduced us to ways of life.

Gardening, for Yvette, is based on feelings. We spoke about the innate urge to push ourselves, to be perfect and want control, but ultimately knowing that we have to let go. You can pick the seeds, plant the fences, choose the paper, load up the paintbrush with great precision, but beyond a point you cannot control weeds from sprouting, branches from twisting, and watercolors from spreading once they touch the paper.

We reminded ourselves to leave room to feel the feelings that drive us and reflected on nature and the processes of creation as ways of being.

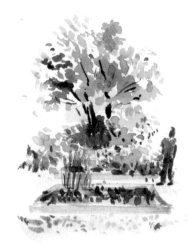

CITY GREEN FARMS

It's always been important for me to work in public spaces.

When people of color come to these gardens, they can see someone who looks like them. When I used to work at Wave Hill in the Bronx, little kids would run up to me. These little Black girls would pick up a dandelion and come to me and say, "I am gardening too."

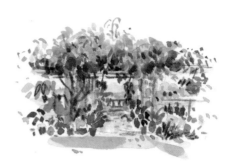

WAVE HILL

FORT TRYON PARK

THE HIGH LINE

THE MET CLOISTERS

Nature is a part of my family.

I don't know if I always wanted to work with plants, but it's always what I've been drawn to and always been a part of my life. Both my parents come from families who worked with plants and animals. My mother's side of the family is Hungarian and German-Jewish, and my great-grandparents were chicken farmers in New Jersey. My grandmother had a huge vegetable garden, an orchard, ornamental plants, and an herb garden. On my father's side, my family is Black American from Georgia, and they had the same connection and that same idea that you can grow your medicine, your food, and can get everything from the land.

I take after my great-aunt from my father's side in many ways. To me she was always Auntie, but her name was Sallie Mae Thompson. She was quiet, she loved to read, she was very lean and had strong arm muscles like I have now. She had a machete that she wheeled around as she would disappear into the woods.

To me, she always looked like she was floating through that space and was in this very deep connection. The trees, the plants, they just all merged. Nature is a part of family; it has been so much a part of who I am. That teaching is so deep. It is looking at family, it is a continuation of who we are.

As kids, we spent a lot of time outside. When my cousins and I think of my aunt, we think of her garden and her connection to nature. We are all vegan. She taught us how to live and eat well. She gave us something that we all carry, an environmental and health consciousness that flows through us all, and that's something that I hope to pass on to my son.

Auntie ↗

*It's ingrained in us somewhere —
the memory of feeling relaxed in nature.
To be able to create a space, especially in urban areas
where everyone can just come & enjoy
is important to me.*

When people used to walk into the Judy Black Garden at
the Met Cloisters, you could just always see that shift in the body
language and that release. Ahhhhhhhhhh. People would weep
and cry and their emotions would come out in the garden. People
needed that.

Designing a garden is different for different people. For
me it is all about feeling. It's about finding balances in color and
texture and it's about finding stories and allowing people to
interact and see individual plants. I enjoy watching people move
through spaces and seeing how they are interacting because
so much of this is about our connections.

*Everyday when I walk out,
its a reminder that I'm working
at the pace of these plants, of this universe
& I don't have control.*

Thank god I work with plants. I would completely burn myself out if I did anything else. I'm working, I can do things, but you could get a frost tomorrow and it would all change. I don't have any control over any of the elements, or time.

We've clearly learned this past year that anything can happen at any moment and just rock the world and throw us all off in a way that we would never expect. I think I see that every day in some little form, being in the garden.

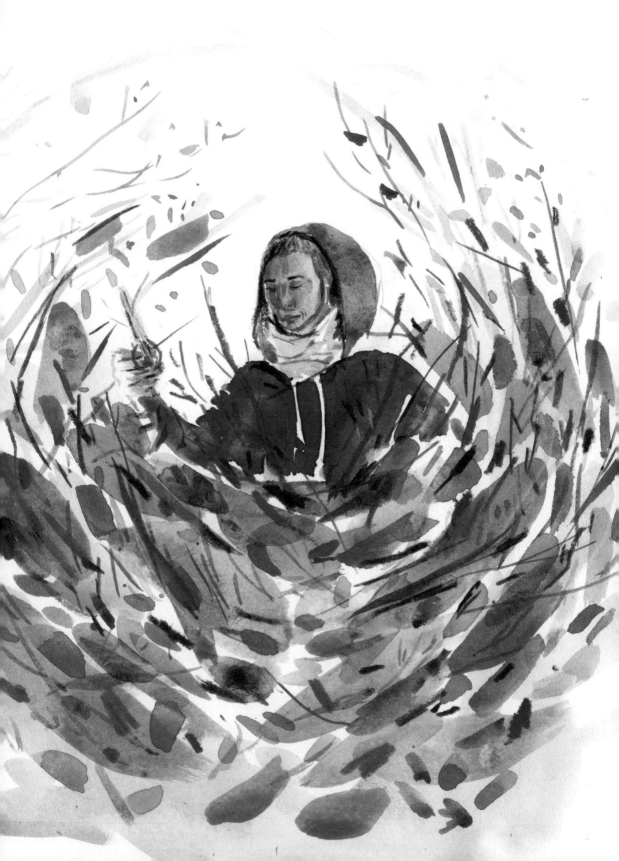

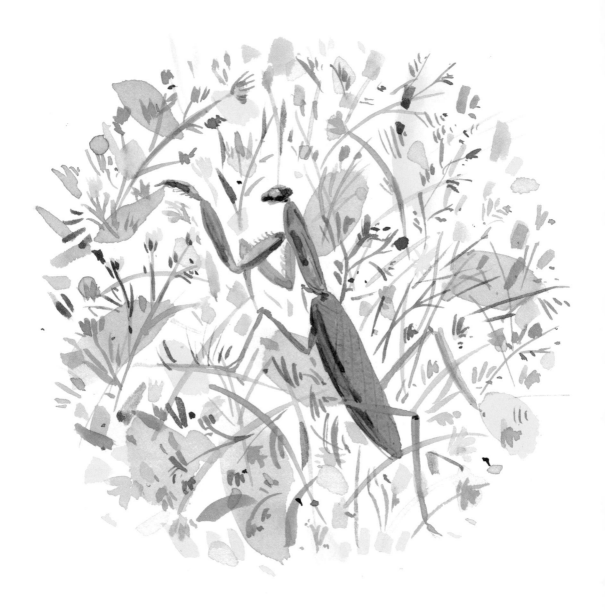

To be able to sit and watch all the birds and pollinators, all the activities happening in these gardens, and to create spaces for all these beings, is really special. I love the lore and history of these plants; they're just like friends. Everyone gets to come to the party here—the humans, the insects, the amphibians, the birds, the plants, it's everyone. When I talk about my aunt, that's what I mean.

We are not separated, we are all a part of this thing. That's what I love & I get to welcome that in.

Understanding the history of earth
is understanding the history of insects.

Dr. Jessica Lee Ware

Entomologist, American Museum of Natural History

I have always been interested in bugs. Our house had a small garden, and I spent a lot of time making concoctions with different ratios of wet and dry sand and mud. Interaction with insects is inevitable if soil is your playground. I loved to "temporarily" catch ladybugs and store them in little origami baskets and then make them race against one another. I tried to catch butterflies by their wings (it took me a while to register that this was actually a horrible thing to do) and I was fascinated by most arthropods, even cockroaches. I was curious to know what lurked beneath these bugs' wings, what their skeletons looked like, and what shiny colors would be revealed if I zoomed in enough.

As a high school student, I really wanted to pursue biology. Unfortunately, the education system in India makes it mandatory in most schools to choose between science, arts, and commerce subjects. So if you wished to study biology, chemistry and physics were part of the deal, and it was a deal that drove me to tears. I ended up switching to the arts, but a latent interest in biology always remained. I fuel that interest through drawing—I love to draw bugs, insects, skeletons, and detailed diagrams.

That isn't the only reason why I decided to speak with Dr. Jessica Ware, curator of invertebrate zoology at the American Museum of Natural History in New York. Dr. Ware's research focuses on the evolution of behavioral and physiological adaptations in insects, with an emphasis on how these occur in Odonata (dragonflies and damselflies) and Dictyoptera (termites, cockroaches, and mantises). Her research group focuses on phylogenetics/phylogenomics and uses these tools to inform their work on reproductive, social, and flight behaviors in insects.

Going back to my mud-flinging days, I've often seen bugs in the vicinity of plants. Their lives are intricately linked together. I wonder if a different lens might offer a new perspective on what we merely see as "plants"—green beings that we see around us. They are homes, they are kitchens, they are furniture, and in terms of scale, they are entire cities for some of these tiny organisms.

I spoke with Dr. Ware about her love for bugs and how they exist in this world in relation to plants around them.

The idea that there was discovery to be done was exciting.

There are more species of insects than anything else, and it got me excited. We have described a million species of insects but there are maybe 30 million out there. Initially I was really interested in marine biology. Within that field, the way my professors described it, it seemed like there was competition and fighting among peers to get access to a single whale for one day a year. By contrast, in an entomology lab, where I did my first research job as part of a work-study program, there were a lot of insects and not enough people to work on them.

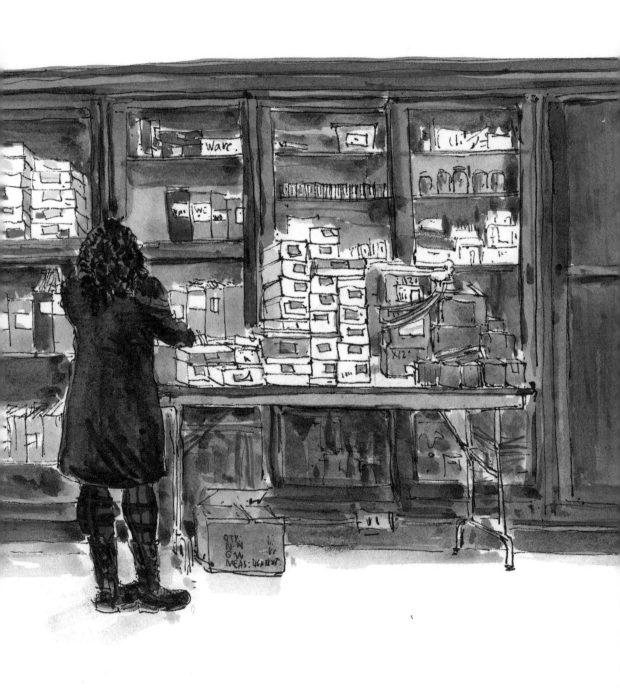

ANOTOGASTER SIEBOLDII (SELYS)
det · Bill Mauffray 2021

GUANGXI ZHUANG REGION : Guilin, Mao'ersman

CHINA
1M

6/10 - viii - 2007 GPS :

Coll : Y. Kishida
IORI # : 00093164

...tude 00 - 1500 m
075

...KE COOK COLLECTION
FLORIDA STATE COLLECTION O...
Proc by : Bill Mauffray 10/30/2021

RHINOCYPHA SANGUINOLENTA LIEFTINCK
det : Bill Mauffray 2021

PHILIPPINES

2M

LUZON : Mimaropa Region Oriental Mindoro,
C...ban, Mt. Halcon

viii ...010 · GPS :

Coll · R...el Cabae
IORI #...09150

Altitude.
000077

Lot # :

...EX CARL COOK COLLECTION
FLORIDA STATE COLLECTION OF ARTHROPODS
Proc by : Bill Mauffray 7/23/2021

At the American Museum of Natural History, we have a collection of 23 million insect specimens, and there are people who have to tend to them, care for them, and also try to grow them. I am responsible for the non-holometabolous insects. These are the insects that don't have complete metamorphosis, like crickets, earwigs, dragonflies, mayflies, grasshoppers, praying mantises, and termites. There is just an egg, then a juvenile stage like a smaller version of the adult, which then just gets bigger. Complete metamorphosis is in the case of caterpillars—that go from an egg to larva to pupa and then butterfly. We have to make sure that the collection is well curated. We go on expeditions and grow the collection and also have exhibitions.

When we go to the field, it is time away from your family or your responsibilities, so that motivates me to make the most of my time. We are not on vacation, but we are here to make observations and collect specimens. We usually start early, and the days are really long. We collect specimens at different time periods. Dragonflies and damselflies are usually out when it's hot in the middle of the day, termites and cockroaches a bit later in the day or maybe even at night. Then there are some dragonflies and damselflies that are crepuscular, so they fly at dawn or dusk. After supper, we usually go out for night hikes or set up a backlight—a sheet with a UV light that shines a bit, like the moon, which lures in the insects we want to collect.

You get to see things that you normally wouldn't. Finding these species is really FUN!

There are twenty-eight to twenty-nine different orders of insects. A million species have been described, and each of those vary in how they view plants. Butterflies are a classic example of a very intense mutualism: they come to drink nectar from plants, get pollen, and then go from plant to plant, allowing for pollination. Bees also do this job, and some cockroaches can also serve the job of pollinators.

For dragonflies and damselflies, plants are a structural feature of the environment that they use to land on or perch on. They are very functional, like a chair is for us. There is also a group of damselflies that use plants as their home.

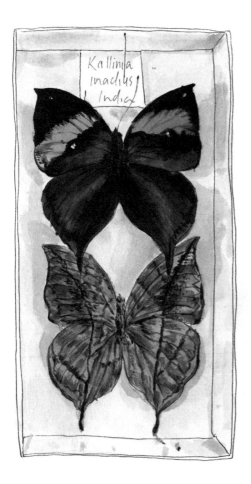

Bromeliads, like pineapples, are plants where water collects among the bracts (leaflike structures from which leaves and flowers grow). All damselflies and dragonflies have juveniles that live in freshwater. The eggs are laid in water, they hatch, and then the nymphs develop in water. The water that these damselflies use is the water stored in bromeliads.

For termites and cockroaches, plants are food. They are also home for termites, some of which live within all types of wood—rotting wood, dead wood, or sometimes living wood. It's everything, it's where they make their galleries (tunnels), it's where their home is, but they are also digesting and eating the cellulose with the endosymbionts in their hind gut. (Endosymbionts are organisms that live within the body or cell of another organism. Residing within the hindguts of a termite are millions of endosymbionts that are essential to the termite's life and help in breaking down and digesting cellulose.) So, for termites, plants are a resource without which they would die. Similarly, for bark beetles and woodlice, plants are fuel. Plants themselves don't benefit from this interaction, but humans do. Every time a plant dies, it would stay forever if not for these decomposers.

All bugs are insects but not all insects are bugs. A bug is an insect which belongs to the order Hemiptera. Hemiptera are also called *true bugs* and they all have sucking mouthparts. Many of them drink the sap of trees or plants with this mouthpart, which is kind of like a straw with a pump at the end of it. They try to mimic what the plant looks like, to avoid being eaten. They look like a thorn or a leaf and use the plant as inspiration over long periods of evolutionary time.

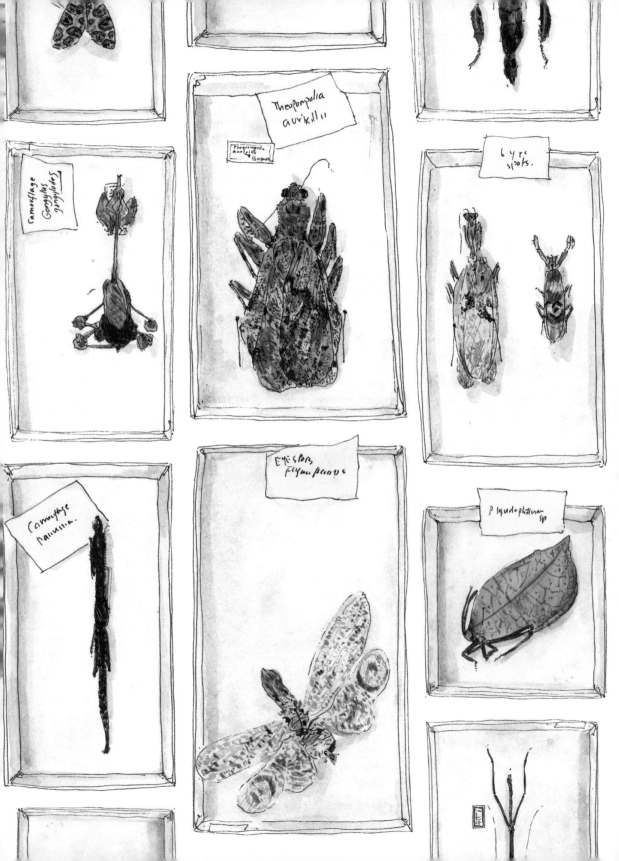

I think people start out really liking insects. It's a learned behaviour to dislike them.

The loss of habitats affects the survival of insects. The impact of the environment on an insect varies a lot by species. There are about the same number of species of dragonflies and damselflies as there are mammals. What would cause there to be fewer cheetahs is different than what would cause fewer pandas. For some dragonflies and damselflies, water quality has a big impact. They are very sensitive to dehydration and need to be in a moist forest. They can dehydrate and die when forests are cut down, but for others having too much forest causes too much shade over water, which can cause some species to drop out.

Any data we collect on insects—when they first arose, how many species there are, how long they persisted, where they live—is good baseline data to compare in times of climate change and catastrophic variation. We still don't know enough about many individual species of say, a dragonfly, to know its role in the ecosystem. In some cases, we don't even know how big the population of a species is. For mammals like cheetahs or pandas we know far more. We know every single panda on the earth, but we don't know that much about insects, so it's hard to know exactly what their impact would be.

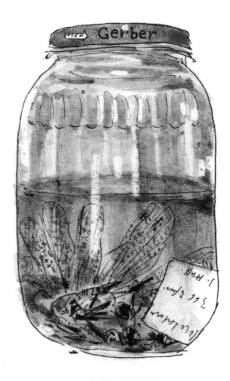

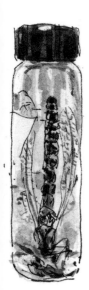

They are probably going to be one of the few sustainable food sources available to humans. They impact almost every aspect of our lives, from making fabric to the food we eat. It's important to remind children, especially when they are impressionable and learning negative things about insects from their parents and caregivers, that insects have been around for a lot longer than we have. There's a whole bunch of them that do different things and they are not out to hurt us. Even bugs that have evolved to live on us, like lice—I mean nobody likes them, not even me, but there are fascinating aspects to all insects, and if you can get people from a young age to really appreciate them, hopefully they won't learn to be afraid of them or to stomp on them. The pendulum swings even further in urban environments if the only insects you encounter are pests that are only seen as things to be exterminated.

Just as trees provide a service of being shady or giving us food, insects are also important. If people are more conscious of these features, and if we made decisions based on the impact that they would have on insects, maybe our species might live a tiny bit longer, otherwise we are on a fast track to going extinct ourselves.

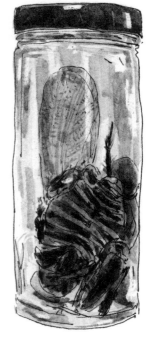

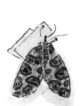

It's important to study evolution
& why we exist.

Insects do a lot of work behind the scenes.

It's hard to imagine human history
in the absence of insects.

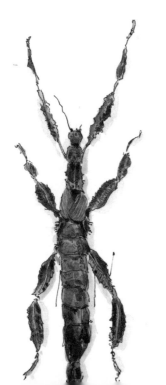

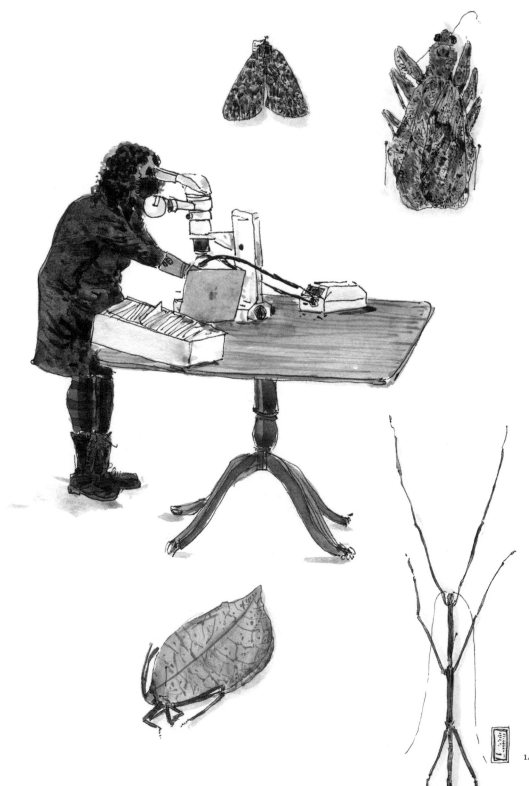

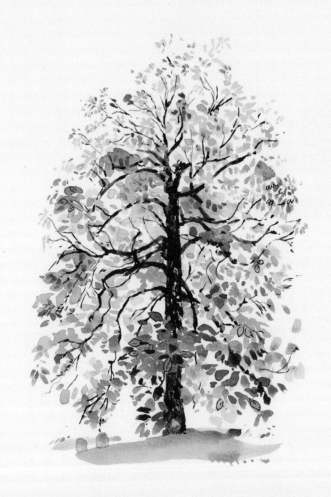

The fact that trees live & die here
reflects the human condition,
that things come & go.

Horticulture Department
Green-Wood Cemetery

Yesterday I went and sat inside a rhododendron. Yes, *inside*. The tree itself looked like a giant bush. No visible trunk, just thousands of leaves arranged in circular patterns giving the appearance of a very large, voluminous bush. You wouldn't think much of it. Nestled in one crevice of the bush was an obelisk, a grave marker.

Sara Evans of Brooklyn's Green-Wood Cemetery brushed aside a few leafy branches and disappeared! I followed. Inside was a whole new world. An enclosed globe of green, filtered light and entangled limbs of thick and thin branches holding the entire structure. A forest within a tree, in a cemetery, in New York, in a forest of buildings. The inside of the tree had a certain darkness, the kind that overgrown forests have from dense tree cover. The smell and sense of the soil was musty and cool. Standing inside this tree, my sense of scale was distorted. It felt like being in a tree-sized bush. The feeling of privacy, of being alone in this living, breathing mass of leaves and branches was thrilling. Wonder and life lurk in unsuspecting places. I found much of both at the Green-Wood Cemetery.

Under and inside some of the spectacular giants at Green-Wood, I spoke with several members of the horticulture department. Here are conversations with Joseph Charap, director of horticulture, Sara Evans, manager of horticulture operations and projects, master pruners Sarah Wells and Luis Cruz, and Jairo Figueroa, a tree crew leader.

Trees make me really happy because
there is this tension —
they are so powerful & also so peaceful.

Their roots up turn foundations, when
they drop a limb, they can cause a lot
of damage yet, they are so
still and so peaceful...

And they're full of secrets.

SARA EVANS, Manager of Horticulture operations & Projects

*The world continues to grow bigger,
the more you look at it.*

Sara Evans (continued)

I've never really seen nature as necessarily a source
of comfort. It's primarily been a source of curiosity
for me, and a way to communicate our social and
cultural history.

Looking at the meadow and taking surveys of the
insects that are foraging flowers you get to know their
behavior; you get to know their preferences. You get
to know what they look like so you're not just increasing
your skill of observation, you're also learning the ways of
the individuals of different species.

The way I think about death has not really changed
much since working here. If anything, it has cultivated
the sense of cherishing and appreciating life.

I'm very fortunate that I have a job that doesn't require me to be indoors all day. It never gets old for me to see the same tree every day. Trees are self-optimizing, so they will shed branches that they don't need anymore. They'll grow in a way that accepts their fate, and they accept where they are planted and what they have to deal with, but they're also adapting to those conditions. They're giant living things that really survived this landscape, they endure what we put them through. It's a sign of the resilience of trees.

The fact that trees live here and die here reflects the human condition, that things come and go. Natural landscapes are so conducive to the grieving process because there's a sense of continuity—even if a tree falls it's created seeds and they can continue.

JOSEPH CHARAP, Director of Horticulture

When I came here for my job interview, I had never been here before and perhaps that had some impact on my perception of Green-Wood. It was a green space first.

For some people, this is always going to be a cemetery, but I perceived it as a green space that was conceived for comfort.

Landscapes like this have a special emotional resonance

CHIRR

CHIRR

CHI

CHI

Joseph Charap (*continued*)

Earlier, when I was getting my master's in literature, my goal was to figure out a way to use literature to connect with people. Eventually that led me to consider medical school, because I felt like I couldn't do it through literature, but maybe I could do it through psychiatry.

I found that even if you don't believe in climate change you can still be easily moved by the loss of a natural landscape. Nature can communicate tough but also very simple truths about the human condition. I don't think many art forms can reach people in the same way.

We're not a traditional botanic garden. A lot of the conservation work we would potentially do is the preservation of mature trees that we have here and to look at the opportunities to sustain this landscape in the future.

This institution has been around since 1838, and it can't be changed from what it is. That's a pretty powerful thing. My vision of this is to be a place of its neighborhood.

CHI
CHI

CHURR

CHURR-CHIRR

Trees grow at such a different pace from humans, and I was curious to know if working with plants and trees can offer a different perspective on day-to-day life. I asked Sarah Wells and Luis Cruz, who are master pruners at Green-Wood, if they had any personal reflections or learnings from the field.

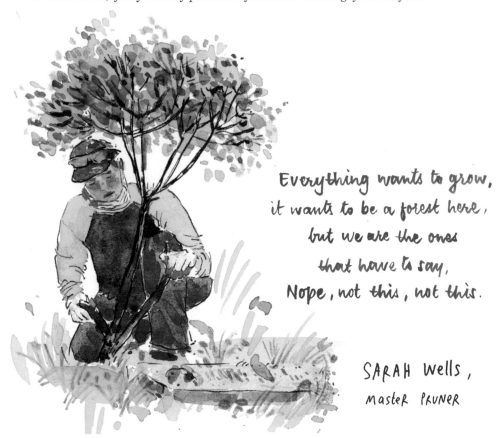

Everything wants to grow,
it wants to be a forest here,
but we are the ones
that have to say,
Nope, not this, not this.

SARAH wells,
master PRUNER

As master pruners, we prune young trees to develop in a healthy way. This is called developmental pruning. A lot of our work is editing what people don't want. This place is trying to regrow as a forest, but you have to balance it with its other purpose as a cemetery, as a green space for the public. You can't have hazardous things, and pathways have to be accessible. It's difficult because I'm always on the side of the trees. They support so much life.

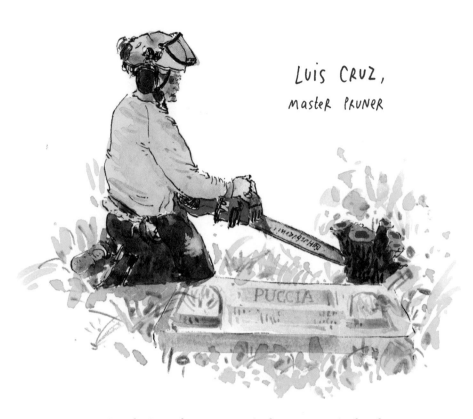

Luis Cruz, Master Pruner

Sarah: One of our mottoes is that everyone's already dead. What's the rush? I am pretty patient but working here I have learned how to be extra patient. I can sense more seasonally. I can tell when winter and fall are coming, way before they arrive. You're outside, you're touching and feeling and smelling things all the time. You are just more in touch with stuff. Fall is the best—you can't beat it. It's beautiful. It's magical.

Luis: All the leaves are changing color.

Sarah: After working outside this long, I can't imagine having a desk job.

Luis: I can never be sitting down.

Sarah: When we work inside, all you're exposed to is an environment that's been cultivated by your bosses. This is also a cultivated environment, but you're part of a web. Of something bigger. I get to see little animals that I love all day and watch things grow and watch things die too.

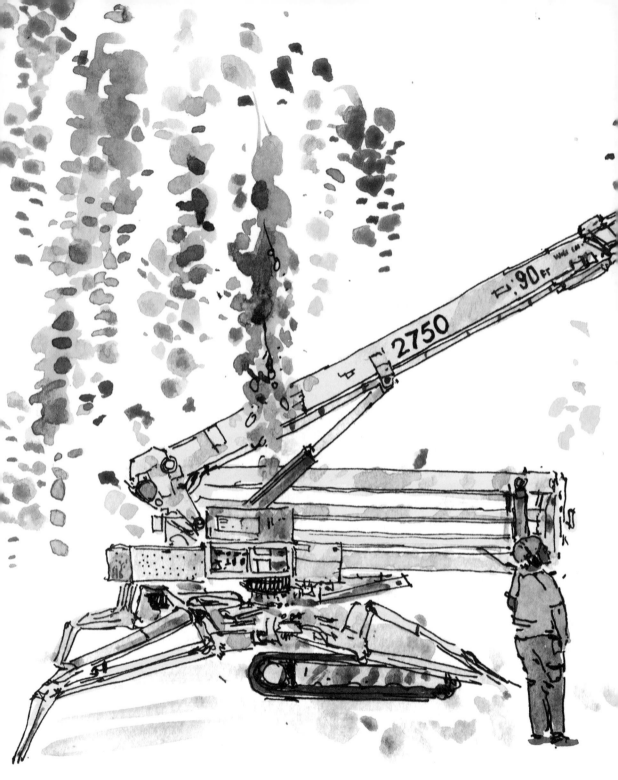

JAIRO FIGUEROA, Tree crew leader

We remove some of the trees that are risky and can cause harm. We do a lot of pruning of veteran trees with wood decay. We work on them to make sure that they can survive for another twenty years. We just removed the dead branches of a tulip poplar that is more than one hundred years old. We could have toppled the whole tree, but we decided to just leave it because the trunk is still intact and there is still life in it. There are animals going in.

Unfortunately, in the beginning I used to like cutting trees. It was exciting. Physical excitement. Now I really think about which trees to cut, and we try to serve them as much as we can. Before, if there was a tree that was dead I would just cut it, but now I think about it, especially because there is all this life in trees. I think there is beauty in huge trees, so we take our time.

I've worked here since 2003 and it pays OK. You do a job to sustain your family, but I think everybody is wired differently. In seventeen years, what fulfills me the most is working with plants. I started in the grave department. I've done cremations, burning people, grave digging. I saw the other roles as a job. Especially last year, all the departments in Green-Wood were closed except graves and cremations. I think everybody lost somebody at some point. When you are cremating, you do see it as a job and get desensitized to a degree, but this is the work that is the most satisfying because there's always life involved in it.

When we see an old tree that is weak, we let it die slowly, and I will make sure that it is safe.

For the triennial, the major theme was
COLLABORATION.
So many different types of people, professions
& technologies intersected to make
these models possible.

Dr. Emily Marshall Orr

Curator, Cooper Hewitt, Smithsonian Design Museum

I visited Nature—Cooper Hewitt Design Triennial in 2019, an exhibition showcasing design and meaningful connections with nature. Complementing the design triennial were two exhibitions, *Botanical Lessons* and *Botanical Expressions*, featuring a rotating presentation of objects from the museum's expansive holdings of over 210,000 objects.

As I walked up the stairs inside the Andrew Carnegie Mansion, where the Cooper Hewitt Museum lives, I was transfixed by a case of what seemed to be vintage, larger-than-life alien creatures. A dog rose caught in full bloom, the eerie cross section of a fig, and a castor bean with strange, spiky appendages reaching for the sky. On closer inspection, they were plant models by R. Brendel & Co., a German firm that made teaching aids in the nineteenth century.

I spoke with Dr. Emily Marshall Orr, associate curator and acting head of product design and decorative arts at Cooper Hewitt, Smithsonian Design Museum. She is also the curator of *Botanical Lessons*. *Botanical Lessons* explores nature in the Smithsonian collections through thirteen botanical models on loan from the National Museum of American History, and a selection of illustrated books and periodicals from Smithsonian Libraries, all of which served as teaching aids in a nineteenth-century period marked by a growing interest in science and education.

While preparing for this exhibition, Dr. Orr and Mina Warchavchik Hugerth, a graduate of the History of Design & Curatorial Studies master's program offered jointly by the Cooper Hewitt, Smithsonian Design Museum, and Parsons School of Design, gathered objects of interest in the collection from the early nineteenth century to the present. They realized that there was a critical mass of interesting materials from the rise of industrialization in the late nineteenth century through the early twentieth century, and as they started to map out designers and objects for this show, they realized that many of those makers were trained in botany. They found direct overlaps in the worlds of science and design and these models are a great example of the collaborative nature of design processes.

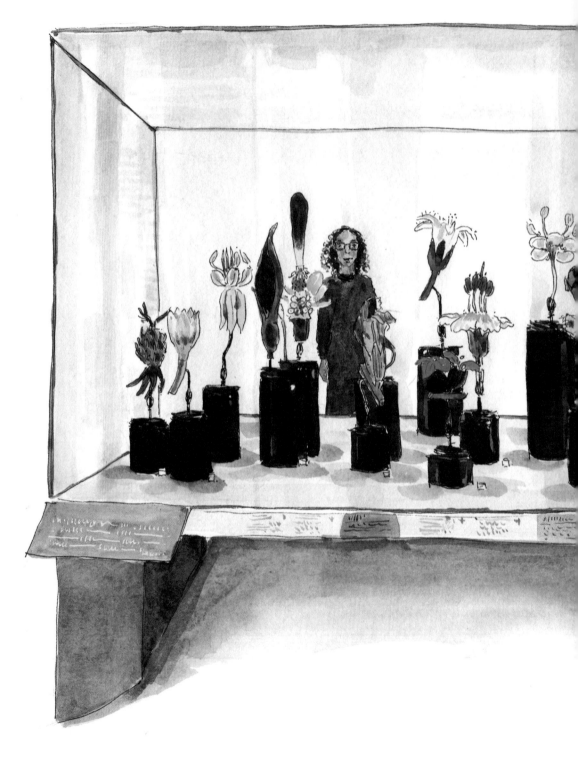

One of my favorite things about being a curator is teaching people the unfamiliar story about something that is familiar to them.

You might not question these botanical models in a natural history museum but seeing them here makes you pause and look at them in a new way. When we look at them as objects of design we can think of design as a tool for education and how design can intersect with so many fields.

I was curious to know what else was happening in the world at that time and why there was a need for these models. These thirteen colorful models, made by the leading German firm R. Brendel & Co., were popular teaching aids for students around the world during the late nineteenth century.

This period was marked by revelations in the field of science—new worlds were found as the planet Neptune was discovered. In our earthly realm, Dmitri Mendeleev created the first periodic table of elements. The understanding of electricity expanded as this period saw the invention of the light bulb, the telephone, the typewriter, the camera, and many other objects that seem mundane now. Louis Pasteur made the first vaccine against rabies. The understanding of life on earth shifted with the idea of evolution when Charles Darwin published On the Origin of Species.

The term scientist *was coined in 1834 and it soon replaced the older term of* natural philosopher, *which reflected a shift in ideologies. In parallel, the boom in industry and large-scale manufacturing processes demanded skilled and educated workers who understood these developments, and there was a heightened interest in education. The fields of chemistry, physics, biology, botany, zoology, and medicine saw a great interest and there was an increased demand for teaching materials in high schools and universities.*

Robert Brendel founded the R. Brendel company in Breslau (currently Wroclaw in Poland). He opened a factory in 1866 to produce botanical models for teaching. He started with a crop of thirty models, and by the early twentieth century they were making about three hundred specimens. Brendel worked with qualified scientists like Dr. Carl Leopold Lohmeyer, a pharmacist, and Professor Ferdinand Julius Cohn, director of the Institute of Plant Physiology at the University of Breslau, to expand his knowledge of botany and model making.

Encyclopedias and periodicals were important sources of botanical research for an increasing number of scientists, professional gardeners, and enthusiasts. These models and illustrations provided up-close views of the natural world at a time when microscopes and image projection were still not widely available. Through these design objects and visual aids, new ways of understanding nature's intricate structures and beauty were possible with the naked eye.

The building of these models brought together so many interesting professions

Dr. Orr explained what the process of building these models was like:

Throughout the process, Brendel expanded connections between the making of the models and the latest scientific knowledge. Inside the catalogs for the models, there is an advisory board of scientists listed. Scientists were consulted to make sure that all the models were anatomically accurate.

At their core is a papier-mâché base that was painted and shellacked. The beads, hair, and the many, many materials listed here were added delicately by hand by the model makers. Many of these models would have come apart and been demountable—you can see seams and hooks in them. All of these are made of many parts that are assembled into a whole.

The shapes would have been made with a mold that could have reproduced the curve of a leaf, exactly the same for, say, a few hundred pieces, and then an individual artist would have come in to do the shading of the beautiful blue to give it its visual appeal.

They were sold with a guidebook and an instruction book and then they entered the classroom and reached students and educators.

Your eye is drawn to these details
& I would hope that you
will notice these textures
more in the outside world.

To me, one of the most amazing things is the incredible amount of materials—wood, papier-mâché, cardboard, plaster, reed pith, metal, string, feathers, gelatin, glass and bone glue beads, cloth, metallic thread, horsehair, hemp, silk threads, paint, and shellac varnish.

I just love picturing the worktable of someone making these and carefully placing all the components. The textures are amazing, you can even see fuzzy and prickly elements.

RICINUS COMMUNIS
1875 - 1898

FICUS CARICA
1875 - 1898

A surreal, slightly disturbing element of these models is that they stop time.

We think of the natural world as being something that grows and changes, but here the whole point was to freeze that at a particular moment when the flower is open in this configuration where the stamens are reaching toward the light that is artificial around them.

THEOBROMA CACAO
1875-1898

ROSA CANINA
1875 - 1898

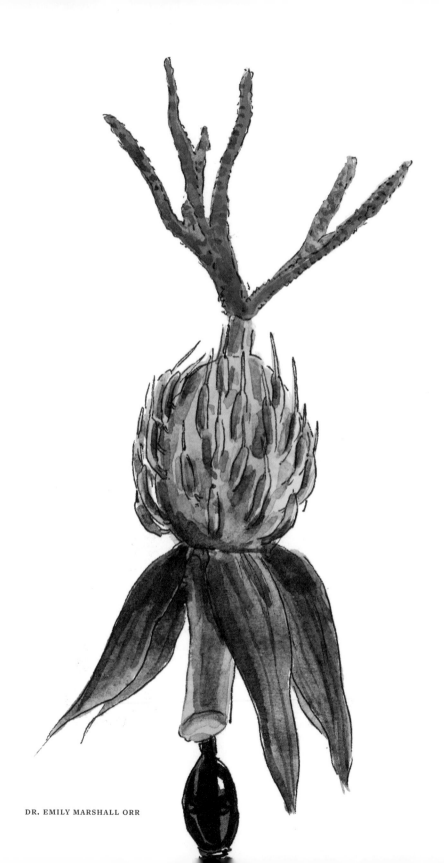

These models celebrated the rise of industry because they were made at this great scale, but at the same time, they were still celebrating this beautiful handmade reality that brings their color & this attention to detail.

For the triennial, the major theme was about collaboration. So many different types of people, professions, and technologies intersected to make these models possible.

Beginning in the late nineteenth century, popular exhibits at world's fairs centered around the theme of botany. The Brendel models were repeatedly displayed as proud examples of German design and tools for scientific education. For decades, the firm earned top recognition at fairs in Paris (1867 and 1900), Vienna (1873), Cologne (1890), St. Louis (1904), and Brussels (1910). At the 1893 World's Columbian Exposition in Chicago, the Brendel models filled the Berlin pavilion, winning a gold medal and amazing an international audience. So, thinking about how important botany was as a field to show at a world's fair, it's great then to bring them back here into the exhibition context.

* References

wikipedia.org
thoughtco.com
cooperhewitt.org
Save the Plants: Conservation of Brendel Anatomical Botany Models
Graziana Fiorini, Luana Maekawa & Peter Stiberc.

Plants make me happy because
of the sense of nurturing.

Puneet Sabharwal
CEO, Horti

One of the first things that Puneet and I connected over was the fact that somehow, in the process of moving countries and leaving big communities behind, being in the presence of nature provided us comfort.

One of the most common house plants in India, *Epipremnum aureum*, is colloquially called a money plant. It is hardy, it can grow in dark interiors, and it will also survive negligent care and watering. It is easy to propagate and is commonly found as a hanging plant or as cuttings in recycled glass bottles on top of refrigerators, cabinets, in shaded nooks, or on tiny windowsills in bathrooms. The same plant goes by the common name of pothos in the US. Puneet said that it was one of the first plants that he bought for himself, and that made me smile because almost every Indian would think of a money plant when they see a pothos.

Puneet is the CEO and cofounder of Horti, which is an online plant subscription service. Puneet and his cofounder, Bryana Sortino, built Horti out of a desire to do something of their own. Both of them were obsessed with plants and often had friends asking for advice on plants. They realized that many people have the desire to bring plants into their lives but lack the confidence to keep them alive. Their subscription model starts with the easiest of plants and when one is able to care for those and cultivate confidence, they slowly start playing with the kind of plants they send out. I met Puneet at the Horti store in Greenpoint, Brooklyn, where we spoke about what it's like to turn something you love into a business.

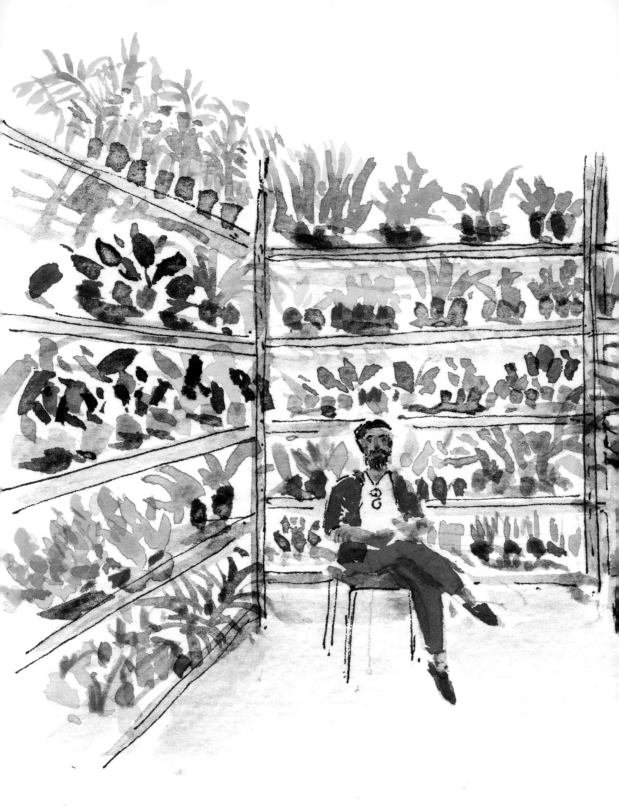

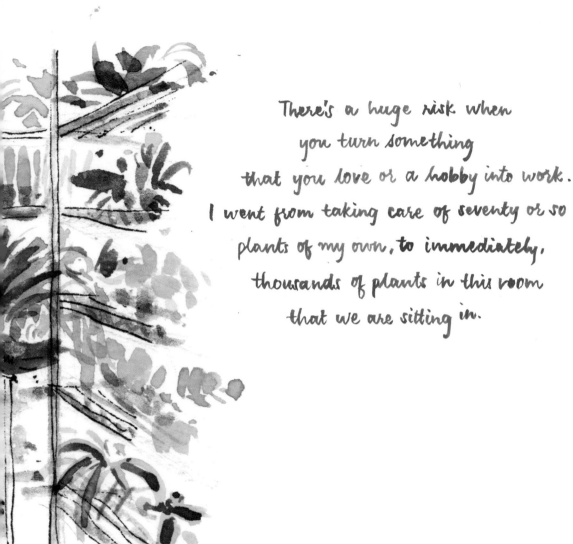

There's a huge risk when
you turn something
that you love or a hobby into work.
I went from taking care of seventy or so
plants of my own, to immediately,
thousands of plants in this room
that we are sitting in.

There was a bit of a readjustment in our day-to-day life where plants started slowly seeming like work. But we had to take a step back and reconnect.

We are a start-up and we have to make money. It's part of the business but both Bryana and I are not inclined toward a capitalistic way of thinking. It's not about pushing plants. You can walk in the door and just have a conversation about plants. We are not trying to convince you to buy anything. After we started Horti, we realized that a beautiful way for people to build an instant connection with their plants is by repotting them.

When we ship the plants, we send the soil separately, and when the first step that you take is putting the plant in the soil, you are already connected with it.

Initially I had the sense that I was taking care of my plants, but I have come to realize that I am the one who is actually being taken care of.

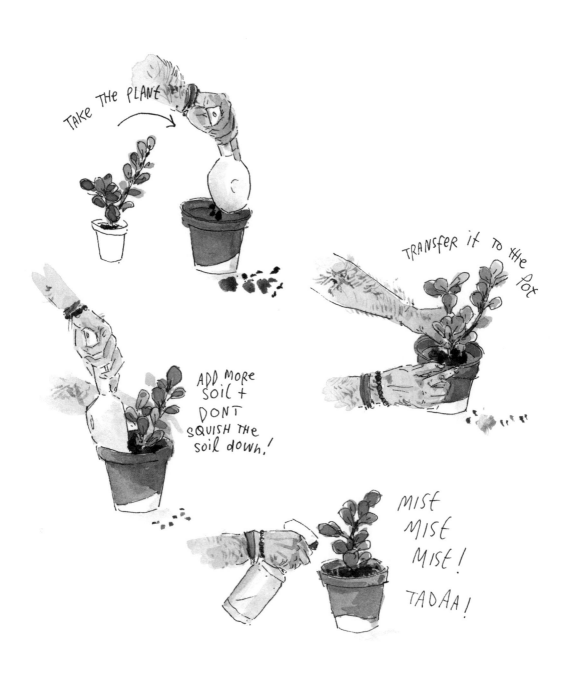

Union Square Greenmarket
New York City

On a crisp and sunny fall morning, I went to the Union Square Greenmarket in Manhattan. If you are ever looking for a pick-me-up, I urge you to come here. Step into a place of growth and greenery, farm flowers and vegetables, and the bustle of morning shoppers. The place was buzzing with energy and left me cheerful and happy from all that I saw.

I unfolded my portable stool and drew in front of pop-up plant and flower stalls. As I watched people crouch down to find the perfect pothos, stand on their tippy toes to eye the liveliest Calathea, or carefully inspect the leaves of the ever-popular Monstera, I couldn't help but wonder, what is bringing all these busy New Yorkers to these green treasures on this Wednesday morning? So, every time I saw someone with a bunch of flowers or plants in their hands I stopped and asked them, "Why do plants make you happy?"

I met a woman carrying a cartful of golden yellow sunflowers and zinnias and bright red chilies. Bursting with volume and color, I saw this shopper with her cart going around the market several times. "I want to spread joy," said Jessica. I saw a mother with her child carrying a gigantic bunch of leaves and flowers as tall as the child. Dressed in richly patterned, green, orange, and maroon pants that vied for attention with the bunch of lush green leaves in her hands, Sheila said that she loved the energy of plants. I saw flowers in bare hands, in woven baskets, in *New Yorker* tote bags, in strollers, and in little wire carts. So much wonder concentrated in a tiny part of this city!

As I left the market laden with baked goodies, a bouquet of sunflowers and marigolds, and a trailing Swiss cheese plant, I thought of my *taiji* and *tauji* (aunt and uncle). All this wonder that I keep looking for, much of it comes from them. They showed me how to find stories in every corner in my hometown of Delhi. In the leaves of the neem trees, in the nests of the weaver birds in the biodiversity park, and in the tombs of long-gone Mughal emperors. They gave me a way to access my surroundings and to find myself in them.

Surroundings change, but to be able to look at places where I am settled in the present through the eyes of a tourist is a gift.

Arturo Benitez, Petal Plants NYC

I wake up at 3 a.m. to avoid the traffic and drive from
New Jersey to reach here by 6 a.m. I am having fun
making a living at the same time.

*When you find something you like to do,
it's not really a job. It's fun.*

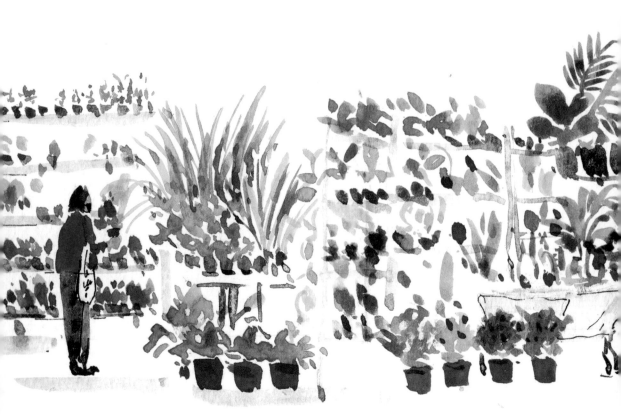

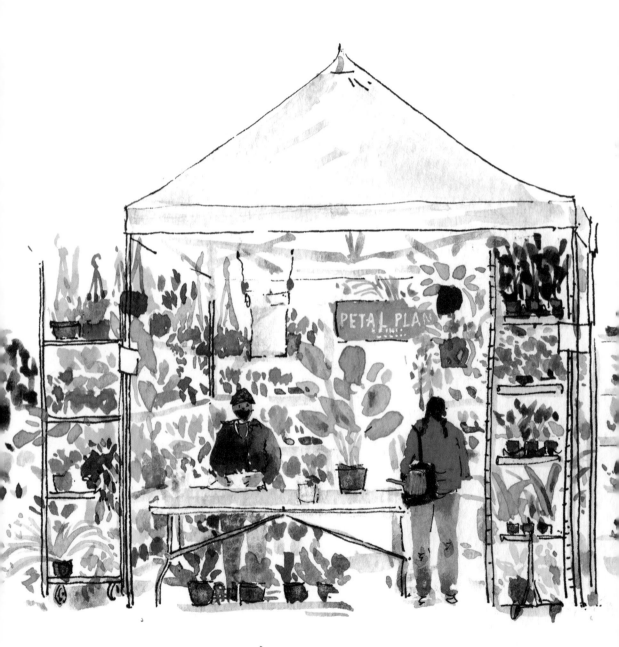

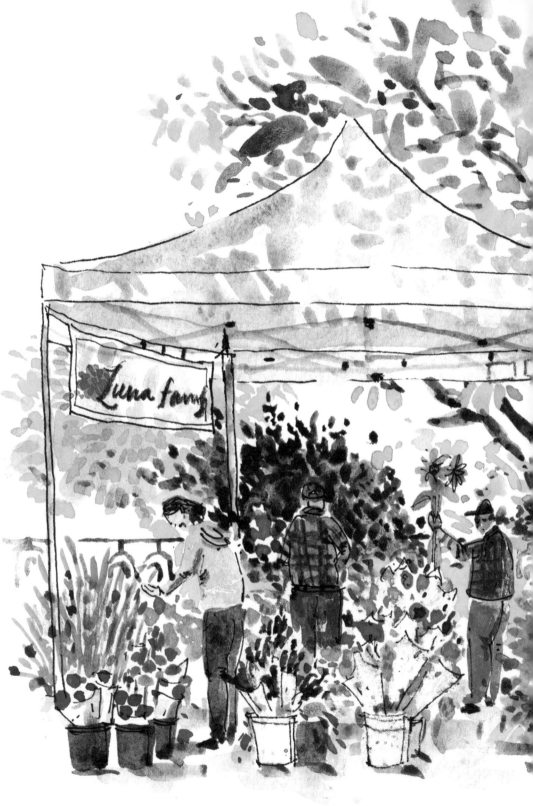

PABLO Jr. & PABLO Sr., LUNA FAMILY FARMS

We have been doing this for thirty years. My father says that flowers are like his kids because this is a family business.

He has seen them, & us,
go from little to big.

Jessica

I was working at an educational community garden for little kids in East New York, Brooklyn, one summer, and we were growing a bunch of vegetables with them, like green beans and herbs and tomatoes, but I also grew flowers. One day, a little girl brought an empty Arizona iced tea bottle and asked if we could make a bouquet that she could bring to her mom. It was just the most fun to go around with her and to make this flower arrangement in the little tea bottle and she went home and brought it to her mom. The next day, all the kids came back with empty bottles because they all wanted to make flower arrangements for their mom. That was when I realized that flowers are such a good way to show love and that you care. That moment made me feel so good I wanted to just keep being able to spread that love and joy.

Leira

Plants remind me of the beauty in the little things, in the simple things, and how there's so much beauty to be found in the ordinary.

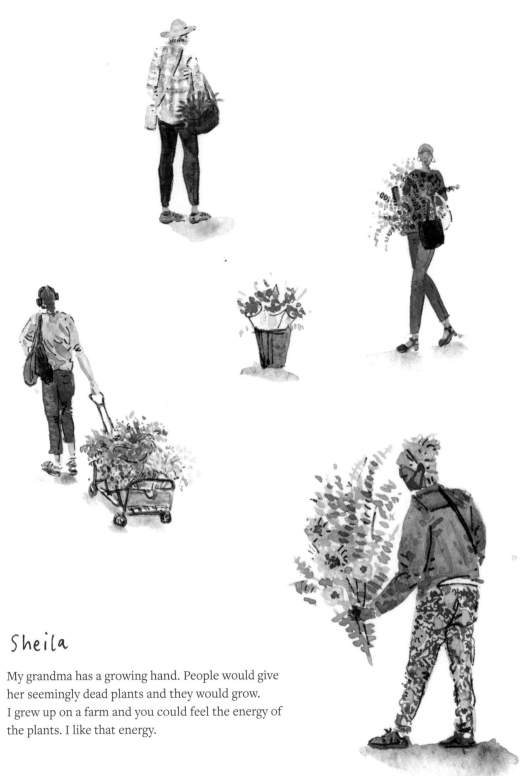

Sheila

My grandma has a growing hand. People would give her seemingly dead plants and they would grow.
I grew up on a farm and you could feel the energy of the plants. I like that energy.

There is no line between who I am
as a scientist & who I am as a person
I don't live two separate lives,
it's all part of one life.
It's who I am & what I would like
to leave behind.

Dr. Ina Vandebroek
Ethnobotanist, New York Botanical Gardens

I had never heard the word *ethnobotany* before, so I was immediately intrigued when I read about Dr. Ina Vandebroek, also a scientist at the New York Botanical Garden (NYBG) and colleague of Dr. Barbara Ambrose (see page 17). An ethnobotanist from Belgium, she has been working in the fields of biology, ethnobotany, and community health. Ethnobotany is the scientific study of the traditional knowledge and customs of a people concerning plants and their medical, religious, and other uses. She has been at the NYBG since 2005 and has conducted research and international cooperation projects in Bolivia, New York City, and the Caribbean.

When I met with Dr. Vandebroek, she told me that she wanted to do this interview because we are seeking the beauty of nature in our own ways, through art and through science, but our common goal is to share and showcase this beauty with the rest of the world. She said that maybe not everyone will feel the same way and become a nature lover, but we can make a concerted effort to showcase how beautiful nature is, and also how fragile it is and how we have been destroying it. To her, respecting something still means that you are a bystander, so maybe we do have to develop a deep love for nature to save it from destruction.

A relationship is defined as the way in which two or more concepts, objects, or people are connected. To love something, one must build a relationship with it, and positive relationships build over repeated interactions over the course of time. My relationship with the magnolia in my neighborhood park has been built over the seasons. We have seen each other every day—bare and tired on short winter days, happy picnics under the summer foliage, and moments of peace and joy under its bursting spring blooms. When I see the first signs of budding on this tree after a long winter, I feel excitement and connection, like I'm about to see a dear friend after a long time! In this way, I've come to care for this being.

Communities all over the world have unique relationships with the environment that they inhabit, and I spoke with Dr. Vandebroek about her own relationship with nature, and her work with different communities and their understanding of health and well-being in relation to the plants that surround them.

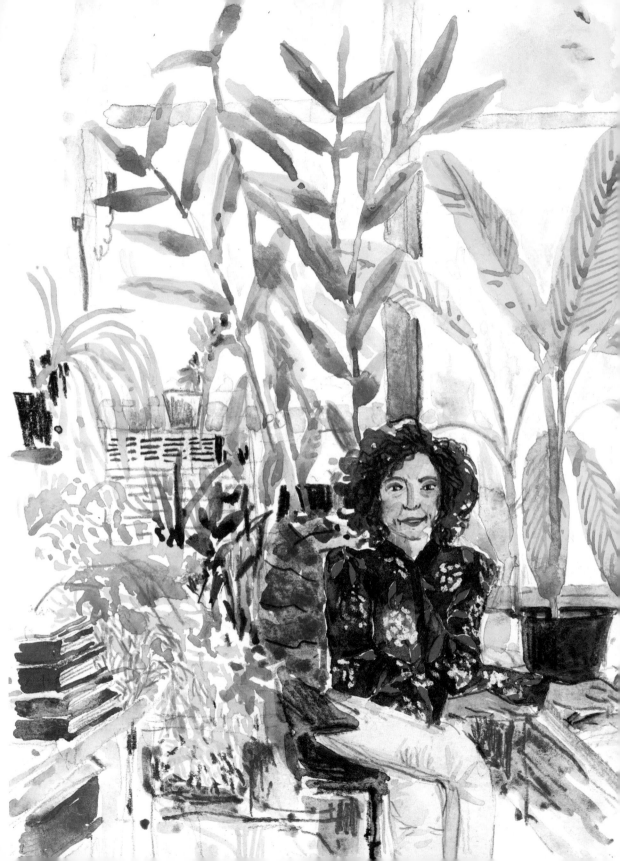

I have a picture of myself as a little baby and I was holding a daffodil. I always loved animals and plants. I would collect plants in the wild and press them. I was the girl who had a little garden and rabbit. I grew salads and carrots in my garden to feed the rabbit, and then I would go and collect little fish from the pond or bring salamander eggs, and my mother would be screaming at me for getting them in the house.

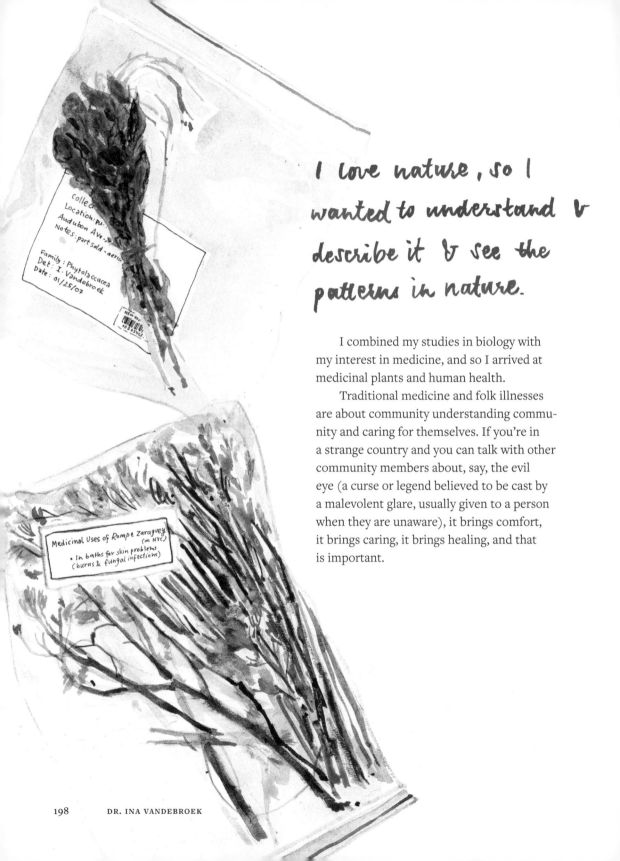

Colle...
Location: Pu...
Audubon Ave-
Notes: part sdd - aeri...

Family : Phytolaccacea
Det : I. Vandebroek
Date : 01/25/07

Medicinal Uses of Rompe Zaraguey
(in NYC)
• In baths for skin problems
(burns & fungal infections)

I love nature, so I
wanted to understand &
describe it & see the
patterns in nature.

I combined my studies in biology with
my interest in medicine, and so I arrived at
medicinal plants and human health.

Traditional medicine and folk illnesses
are about community understanding commu-
nity and caring for themselves. If you're in
a strange country and you can talk with other
community members about, say, the evil
eye (a curse or legend believed to be cast by
a malevolent glare, usually given to a person
when they are unaware), it brings comfort,
it brings caring, it brings healing, and that
is important.

It is not something that is static, it's not frozen in time, and it continues to evolve. It is modern because people are now incorporating plants that treat diabetes, high blood pressure, cancer, and heart disease, so it actively responds to changing epidemiology. People experiment and observe. In western medicine we are taught that a doctor knows everything and a patient should just surrender to that, but here it's the community that diagnoses and so it gives power back to the people.

Traditional medicine is something that has sustained humanity since forever. It has been promoted that everything that is technological is better than anything that is natural, which I disagree with. Even in the case of mental health, you can prescribe people to walk in the garden or pick up gardening instead of pumping them full of pills.

I'm not advocating that any plant can be taken however, but pills also have side effects! People take pills so religiously, like they are following a religion. So why don't we make nature an official religion?

When I'm in the forest, I feel happy.

I like wild environments better than anything man-made or controlled. I think nature is perfection as it is without us needing to dominate it. When I am in the forest I feel very present in the moment, whereas here I'm always thinking about the next challenge, the next deadline, the next report. When I'm there I feel that time stands still, I can withdraw from that very demanding society, especially in science.

It's art, it's beauty, it's shelter—it almost makes me cry. It is as close to religion as I'll ever get. I think nature for me is that sense of divinity. It's my inspiration, it's my religion, my sense of why I think life is worth living. It gives you meaning, it gives you identity, it tells the story about who you are, and I think my work tells that story.

A walk in
RIVERSIDE PARK

It is very much a part of my Indian nature to actively seek the sun in winter. In my previous apartment, a patch of sunlight would stream through the window above my radiator for a total of twenty minutes a day. I would cling to it, like a magnet, till the light inevitably got swallowed by shadow.

During the course of the pandemic, I started going for a walk to Riverside Park every day to escape the unchanging walls of my dark apartment. Every evening, I would go in search of the sun to bid it goodbye before it submerged into the river (or more accurately, New Jersey).

This park is long and narrow. It runs along the Hudson River from 72nd Street till 158th Street.*

*Phase 2 and 3 of Riverside Park South stretches from 62nd to 70th Street and parts of it are currently under construction.

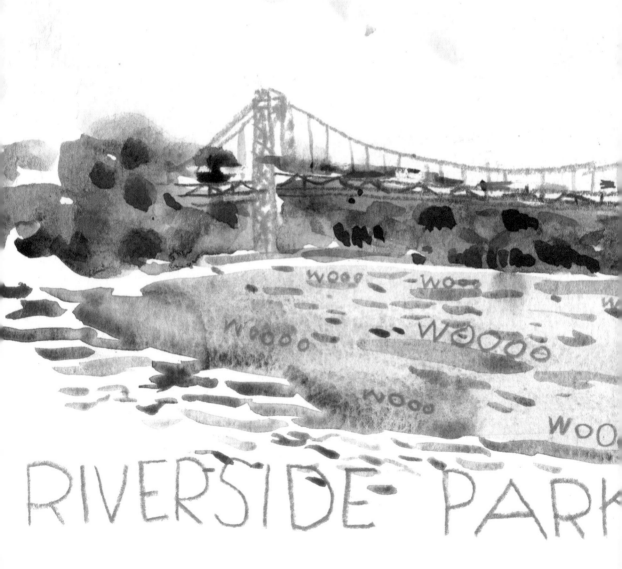

RIVERSIDE PARK

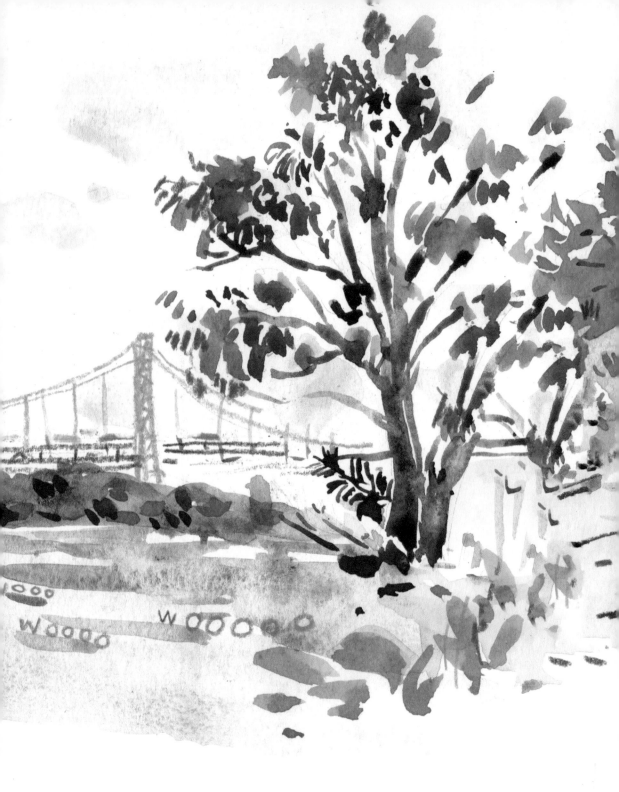

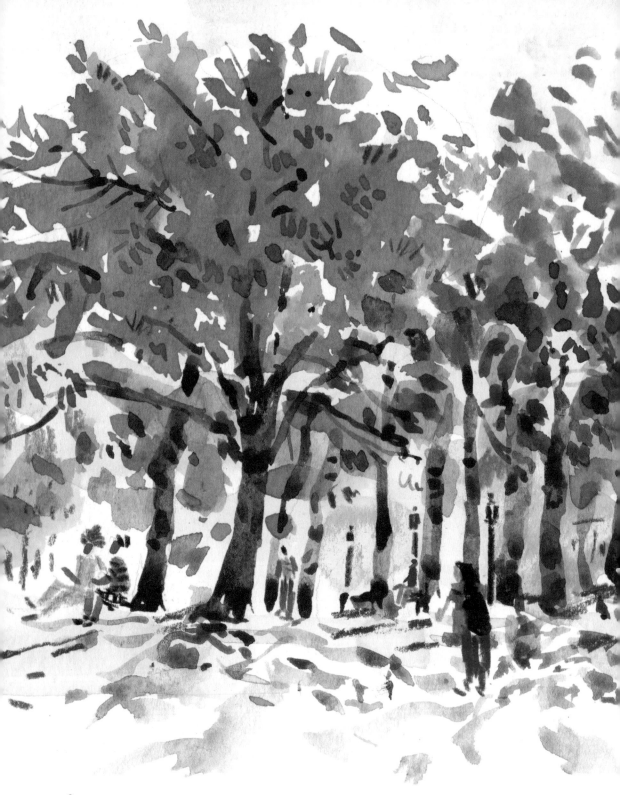

ISHITA JAIN

Unlike the curving contours of Central Park, this park flows smoothly. No sudden turns, no rushed road crossing, and no overwhelming decisions. Just up or down in a straight line. I feel cocooned when I walk under a tight canopy of trees. The park feels dense and enclosed, hugging me and holding me tighter. It feels personal and private. This park gives me space to think.

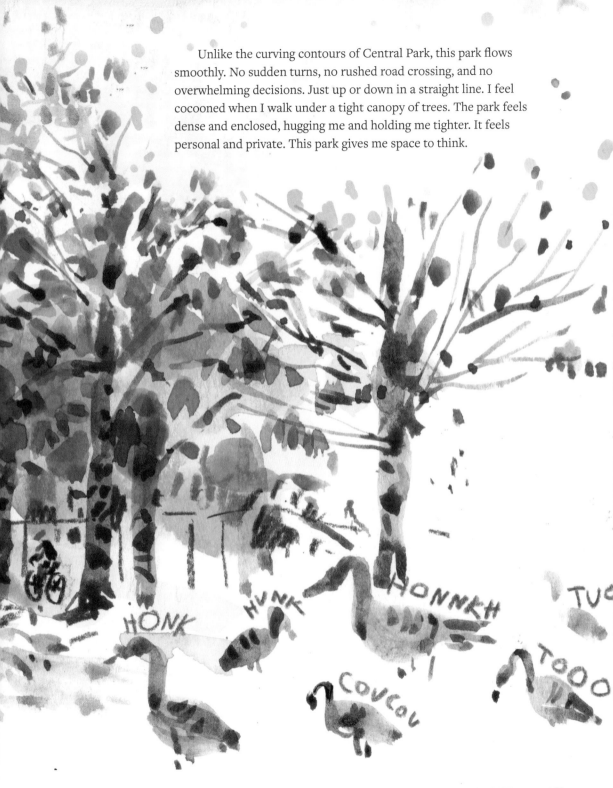

As the sun tilts further around its axis and the dreaded daylight saving time approaches, my routine begins to revolve around the sun. My mealtimes, work routines, and my thought processes arrange themselves around a late afternoon walk to get the last of the golden hour.

I have learned that if you'd like to go for a walk in the southern end of Central Park in peak winter, you better be there by 3 p.m.—any later, the "Billionaires' Row" of skyscrapers along 57th Street will engulf you in its shadows. No need to despair if your meeting ran a bit late, there is always a little more sun over the Hudson for another hour if you can make it to Riverside Park.

These walk times adjust and evolve along with the changing sunsets over the course of the seasons.

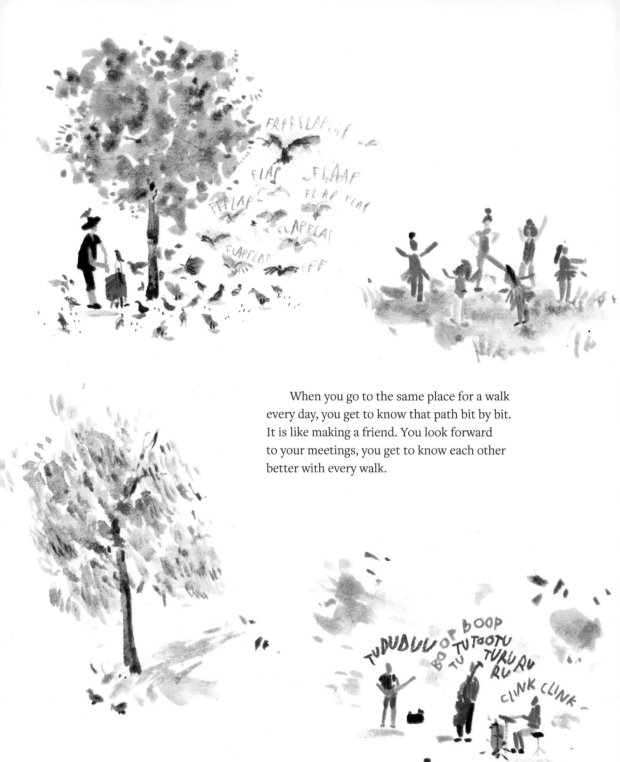

When you go to the same place for a walk every day, you get to know that path bit by bit. It is like making a friend. You look forward to your meetings, you get to know each other better with every walk.

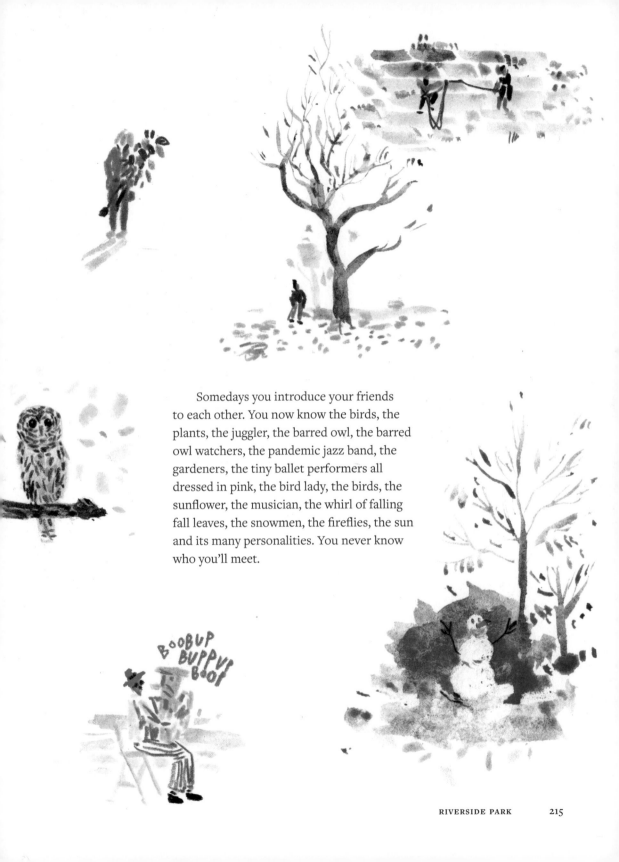

Somedays you introduce your friends to each other. You now know the birds, the plants, the juggler, the barred owl, the barred owl watchers, the pandemic jazz band, the gardeners, the tiny ballet performers all dressed in pink, the bird lady, the birds, the sunflower, the musician, the whirl of falling fall leaves, the snowmen, the fireflies, the sun and its many personalities. You never know who you'll meet.

BOOBUP
BUPPUP
BOOP

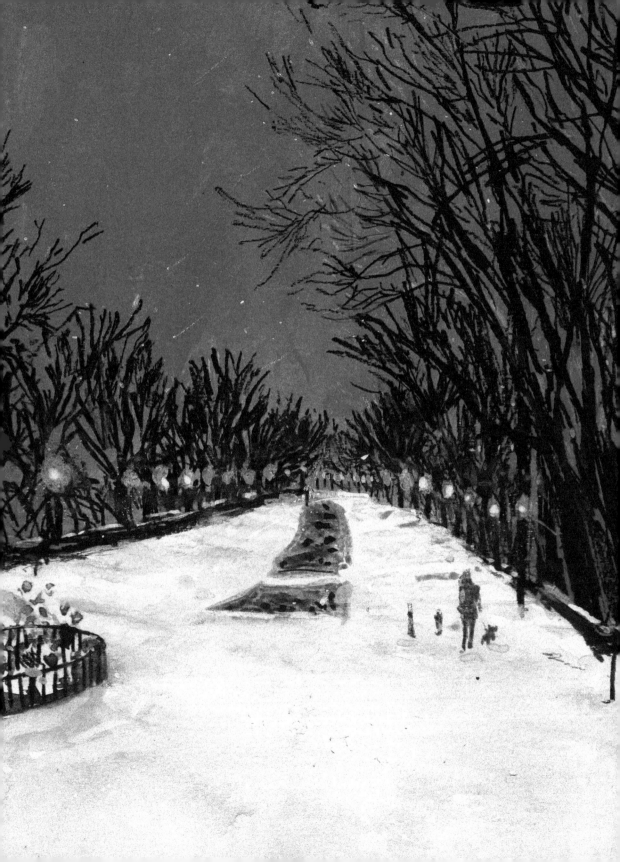

Even on the worst days,
walking is a respite.
For a bit, I can run away
to the different corners of my mind.

While walking in the park I met Anastasia Galkowski, who is the sustainability manager at Riverside Park Conservancy. She says, "I suppose winter is the season of deaths. Death isn't necessarily bad, it's part of the cycle of life. It is a time when the park is a bit more exposed, and your body is also exposed to the elements. Time moves differently and the quality of light is different in the winter. I personally love living in seasonal climates. The winter is as cold as it is short, and the days are charged because it's a time of death and withdrawal."

It's an inhale & you know that the exhale is to come with spring & summer.

ANASTASIA GALKOWSKI
Sustainability Manager, Riverside Park Conservancy.

I had never lived in such weather contrasts before I moved to New York. In the spring, every time I step out it feels like there is something new—there is change in the air, and every day is a surprise. After the long, drawn-out winter, I am so aware of this accelerated pace of life.

Experiencing and observing these seasonal changes teaches me so much about the world. Before I lived here, I never had the language or experience to articulate these feelings. So far, I had only noticed the change in wardrobe with the change in weather, but now I am far more aware of the rhythms of nature and how much I am in sync with them. The warmer winds, the deeper golden sun, the shower of pink blossoms—how can you not be affected when you too are a part of nature?

It feels surreal to have your head surrounded by radiant blooms. It feels like I am alone, encapsulated inside another world, a cocoon of blossoms. An entire ecosystem at work at arm's length, all above my head. Amid the chaos in the world, what a blessing to be able to stick my head under this living, breathing being to get a fresh perspective on another scale of life.

THANK YOU to the BIRDS, BEES, TREES, SEAS, LEAVES, PARKS, WINDS, SEEDS, FLOWERS

MOM, DAD, TAUJI, TAUJI, SOMU, DADI - THE WHOLE NARAINA FAM

the late MARSHALL ARISMAN, CARL TITOLO, KIM ABLONDI, DAVID SANDLIN

SVA MFA illustration CREW

ANNA RAFF, VIKTOR KOEN

MIRKO ILIC, GREGORY CRANE, MATTHEW RICHMOND, CHRIS COUCH, MICHELE ZACKHEIM

CAROL FABRICATORE (who changed how I DRAW ♥) & all my wonderful classmates

WENDY MAC - ADVISOR, MENTOR, INSPIRATION & someone who makes me look fwd to

GROWING UP

GIVER of HUGS, MOST ORGANIZED PROJECT MANAGER & chef,

PANIC SOOTHER & best

partner— ANI !!!

SUPPORTIVE & EVER SMILING

my lovely agent— ERYN KALAVSKY

THE SUPER ORGANIZED, PATIENT

& FANTASTIC— HOLLY LA DUE, my editor at PAP

A.D. PAUL WAGNER for

Patiently WORKING ON the COMPLEX DESIGN of this BOOK with me,

KRISTEN HEWITT &

the entire team at P.A.P. TY to my personal ADVISORY BOARD of FRIENDS for

their time, OPINION & ♥ - PUPU, LNOM, SOMU, SHREYA, BORIS

ALL the V. GENEROUS

HUMANS I INTERVIEWED— ALEJANDRO, CHEN LI, TARAH, RHODA,

GEORGIA, JOSE, ALEX, TAMA,

DR. BARBARA, CECILIA, SAMANTHA, TYNISHA,

JESS, STACY, YVETTE, DR. JESSICA, JOSEPH, SARA, SARAH, LUIS, JAIRO

DR. EMILY

PUNEET, ARTURO, PABLO, JRESR, JESSICA, SHEILA, LEIRA, DR INA & ANASTASIA & VALERIE

WONDERFUL BOOK PEOPLE— JESSECA SALKY & TEAM SLM (the best!), CHARLOTTE SHEEDY

LEAH THOMAS, LAURA LEE MATTINGLY, KATE WOODROW, JULIA ROTMAN

Staff at LANG HAND THERAPY & DR. BRIJESH SIWACH & AARON HOLBY

for KEEPING MY HANDS & SHOULDERS FUNCTIONAL !!

SRIJ & AMELIA M. HOLT

for your HEALING PRESENCE RIVERSIDE PARK!!! the

GARDEN PEOPLE

CUPS of CHAI, RAIN CLOUDS, BAGS of CHIPS

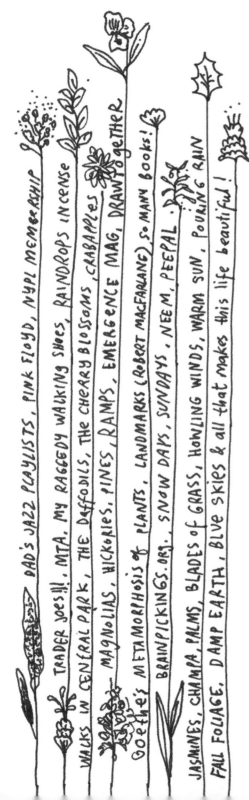

DAD'S JAZZ PLAYLISTS, PINK FLOYD, NYPL MEMBERSHIP TRADER JOE'S!!!, MTA, MY RAGGEDY WALKING SHOES, RAINDROPS INCENSE WALKS IN CENTRAL PARK, THE DAFFODILS, THE CHERRY BLOSSOMS, CRABAPPLES MAGNOLIAS, HICKORIES, PINES, RAMPS, EMERGENCE MAG, DRAW TOGETHER Goethe's METAMORPHOSIS of PLANTS, LANDMARKS (ROBERT MACFARLANE) So MANY Books! BRAINPICKINGS.ORG, SNOW DAYS, SUNDAYS, NEEM, PEEPAL JASMINES, CHAMPA, PALMS, BLADES of GRASS, HOWLING WINDS, WARM SUN, POURING RAIN FALL FOLIAGE, DAMP EARTH, BLUE SKIES & all that makes this life beautiful!

Published by
Princeton Architectural Press
A division of Chronicle Books LLC
70 West 36th Street
New York, NY 10018
papress.com

Editor: Holly La Due
Design concept: Ishita Jain
Typesetting and layout: Paul Wagner

Library of Congress Cataloging-in-Publication Data
Names: Jain, Ishita, author, illustrator. | MacNaughton,
 Wendy, author of foreword.
Title: Searching for sunshine : finding connections with
 plants, parks, and the people who love them / Ishita Jain.
Other titles: Finding connections with plants, parks,
 and the people who love them
Description: New York, NY : Princeton Architectural Press,
 [2023] | Summary: "A thoughtfully researched visual
 exploration of our connections to nature, and why and
 how plants and green spaces make us happy"—
 Provided by publisher.
Identifiers: LCCN 2022032503 (print) | LCCN 2022032504
 (ebook) | ISBN 9781797222493 (hardcover) | ISBN
 9781797224176 (ebook)
Subjects: LCSH: Human-plant relationships. | Human
 ecology—New York (State)—New York. | Natural
 areas—New York (State—New York. | Urban parks—New
 York (State)—New York.
Classification: LCC QK46.5.H85 J35 2023 (print) | LCC
 QK46.5.H85 (ebook) | DDC 581.6/309747—dc23/
 eng/20220808
LC record available at https://lccn.loc.gov/2022032503
LC ebook record available at https://lccn.loc.gov/2022032504